Drawing

Teach Yourself VISUALLY™

Drawing

Visual®

by Dean Fisher and Josephine Robinson

BICENTENNIAL
1807
WILEY
2007
BICENTENNIAL

Wiley Publishing, Inc.

Teach Yourself VISUALLY™ Drawing

For general information on our other products and services or to obtain technical support please contact our Customer Care Department within the U.S. at (800) 762-2974, outside the U.S. at (317) 572-3993 or fax (317) 572-4002.

Wiley also publishes its books in a variety of electronic formats. Some content that appears in print may not be available in electronic books. For more information about Wiley products, please visit our web site at www.wiley.com.

Library of Congress Control Number: 2007921822

ISBN: 978-0-470-06715-4

Printed in the United States of America

10 9 8 7 6 5 4 3 2 1

Book production by Wiley Publishing, Inc. Composition Services

Wiley Bicentennial Logo: Richard J. Pacifico

Praise for the Teach Yourself VISUALLY Series

I just had to let you and your company know how great I think your books are. I just purchased my third Visual book (my first two are dog-eared now!) and, once again, your product has surpassed my expectations. The expertise, thought, and effort that go into each book are obvious, and I sincerely appreciate your efforts. Keep up the wonderful work!

—*Tracey Moore (Memphis, TN)*

I have several books from the Visual series and have always found them to be valuable resources.

—*Stephen P. Miller (Ballston Spa, NY)*

Thank you for the wonderful books you produce. It wasn't until I was an adult that I discovered how I learn—visually. Although a few publishers out there claim to present the material visually, nothing compares to Visual books. I love the simple layout. Everything is easy to follow. And I understand the material! You really know the way I think and learn. Thanks so much!

—*Stacey Han (Avondale, AZ)*

Like a lot of other people, I understand things best when I see them visually. Your books really make learning easy and life more fun.

—*John T. Frey (Cadillac, MI)*

I am an avid fan of your Visual books. If I need to learn anything, I just buy one of your books and learn the topic in no time. Wonders! I have even trained my friends to give me Visual books as gifts.

—*Illona Bergstrom (Aventura, FL)*

I write to extend my thanks and appreciation for your books. They are clear, easy to follow, and straight to the point. Keep up the good work! I bought several of your books and they are just right! No regrets! I will always buy your books because they are the best.

—*Seward Kollie (Dakar, Senegal)*

Credits

Acquisitions Editor
Pam Mourouzis

Project Editor
Donna Wright

Copy Editor
Marylouis Wiack

Editorial Manager
Christina Stambaugh

Publisher
Cindy Kitchel

Vice President and Executive Publisher
Kathy Nebenhaus

Interior Design
Kathie Rickard
Elizabeth Brooks

Cover Design
José Almaguer

Photography
Dean Fisher and Josephine Robinson

About the Authors

Dean Fisher (Milford, CT) is an instructor at the Silvermine Guild Arts Center, where he teaches drawing and painting. He is a graduate of the American Academy of Art in Chicago, Illinois, and has been featured in individual and group exhibitions around the United States and in Europe. He has exhibited at the Tatistcheff Gallery in New York City and most recently with Hirschl & Adler Modern, also in New York City.

Josephine Robinson (Milford, CT) also teaches at the Silvermine Guild Arts Center. A London native, she received her art education in the United Kingdom and previously taught at the University of Tennessee. Her work has been exhibited in London; Chicago, Illinois; Greenwich and New Haven, Connecticut; and Knoxville, Tennessee.

Acknowledgments

We hope we have created a book which will inspire the reader, through the ideas and imagery presented, to find the process of becoming a skilled artist less frustrating and more enjoyable.

We would like to acknowledge the contribution of all the artists who took part in this project by generously allowing us to reproduce their work.

Also, thanks to our editors Pam Mourouzis and Donna Wright from Wiley Publishing for their friendliness and patience during this process.

Table of Contents

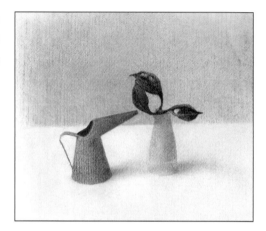

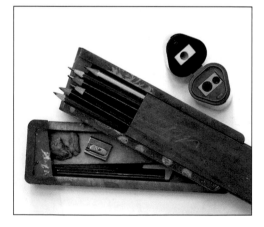

chapter 3 In the Studio

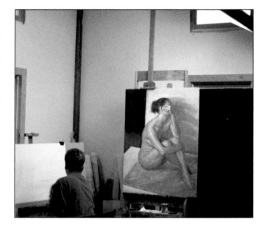

chapter 4 Prepare to Draw

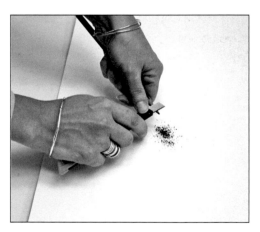

chapter 5 Discover the Pattern of Light and Shadow

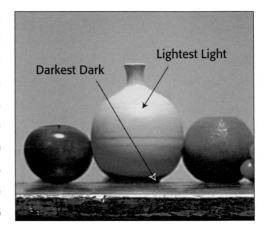

Lightest Light

Darkest Dark

chapter 6 Introduction to One-Point Perspective

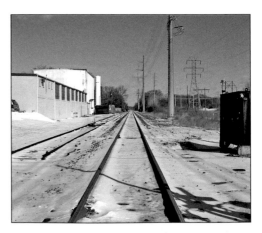

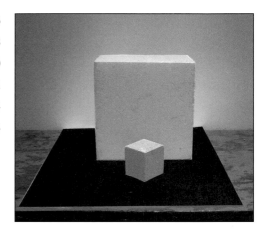

chapter 8 **Discover the Potential of Line**

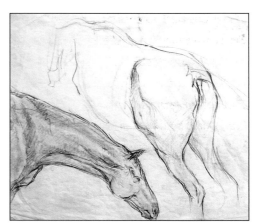

chapter 9 Planar Rendering of Complex Forms

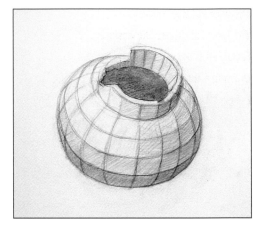

chapter 10 Draw a Plaster Cast

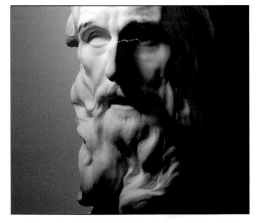

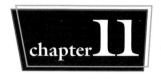

chapter 11 The Portrait

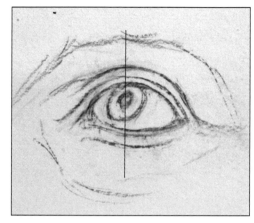

chapter 12 Drawing the Human Figure

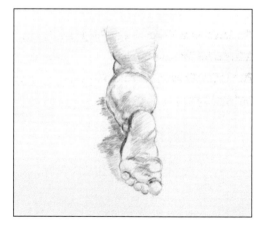

chapter 13 The Landscape

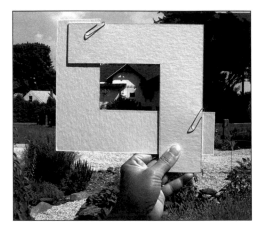

What Is Drawing?

Drawing is a very personal endeavor. Here, in this short introduction, the authors introduce ideas and motivations as to why they are attracted to the art of drawing.

In this phenomenal drawing by contemporary Spanish artist Antonio López Garcia, his acute vision, skills, and patience have enabled him to create this seemingly simple depiction of a real space. While the degree of realism is very high, he has managed to create a breathable space and sense of warmth by sharply focusing only on certain selected objects. This is a scene that is perceived by a human eye, rather than by the lens of a camera.

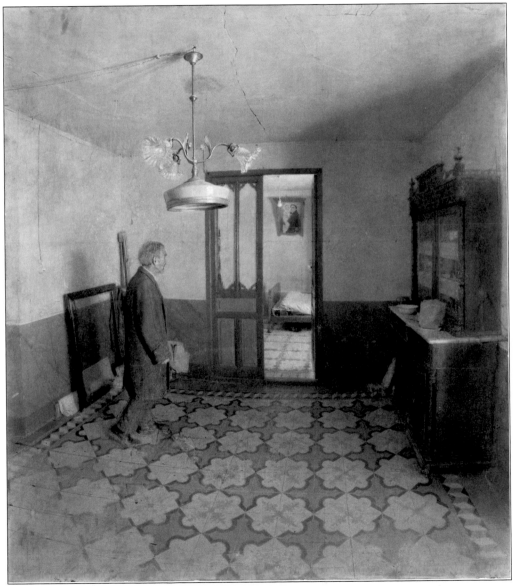

Antonio López Torres' House, *by Antonio López Garcia,* © *VEGAP*

CONTINUED ON NEXT PAGE

This formal, yet subtle, composition fixes our gaze on two objects that are bathed by a soft directional light. The light is gently portrayed by soft tones of gray. The few dark tones in this drawing, and the rectangle of gray behind the objects, are strategically placed to act as weights to anchor the objects into the composition. The gray tones subtlety contrast the light and the half light. This creates a shimmering effect, so that there is a gentle vibration throughout the whole composition.

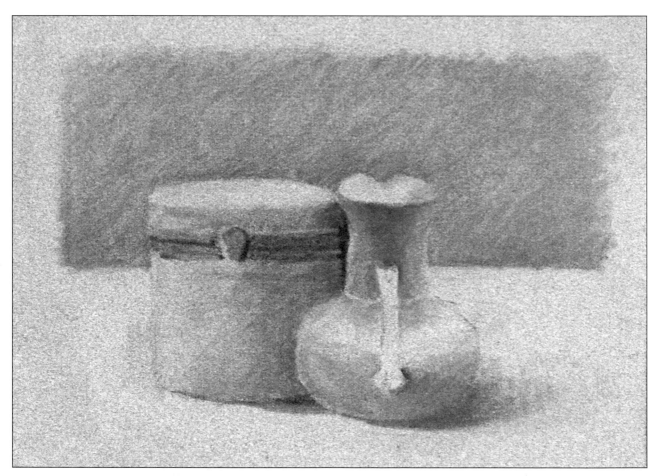

Still Life, by Constance Lapalombara, courtesy of the artist

In this image, the artist has frozen a moment in time. The tumbling cups have been prevented from falling and are locked in position, defying gravity. It is an illusion created by the artist but made believable by his reference to real objects. There are no strongly differentiated tones in this drawing. Instead there is a gentle progression from the white of the cups to the grays of the cloths to the blacks of the cups. It is this use of measured tones that persuades the viewer to contemplate a seemingly unimportant action.

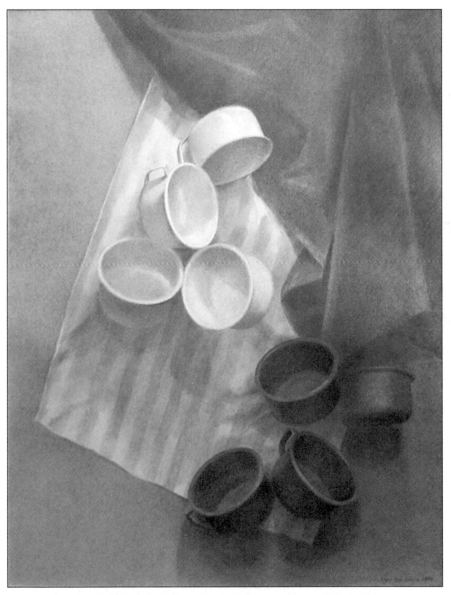

Cup Still Life, *by Roger Van Damme, courtesy of the artist*

2

Drawing Materials

In this chapter, you will be introduced to the basic materials needed to carry out the exercises in the book. The list of choices is rather basic so that you can keep things simple at this beginning stage.

This is a sampling of the many tools that are available to use in drawing. The items presented here have proven to be indispensable to artists. In this section, you will learn each tool's different applications. Take special note of how the tool is used differently by each artist in the gallery sections throughout this book, and practice what you see.

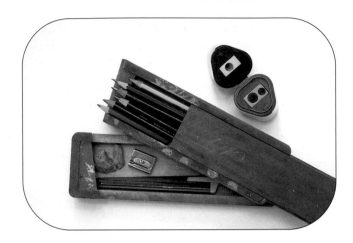

Various Mediums

GRAPHITE PENCILS

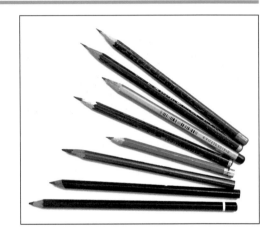

Graphite pencils are probably the most common drawing tool. They are available on a scale from hardest to softest. The scale ranges from 10H to 9B, where H denotes hardness and B indicates softness (the B refers to black). An H pencil makes a sharp and precise line. As the H number decreases, so does the sharpness. With the B range, the higher the number, the softer and more blurred the line becomes.

You can also buy water soluble graphite pencils. You draw out your image with the pencil, and then paint over areas with a brush that has been dipped in water to soften passages of tone, or line. This will give your drawing a more "painterly" look.

Note: *Graphite can be easily erased, as long as you don't press really hard when you draw. A jar of graphite powder (see the photo on page 36) is excellent for creating a ground, or tone, on your paper. You'll learn more about tone in Chapter 4.*

CHARCOAL

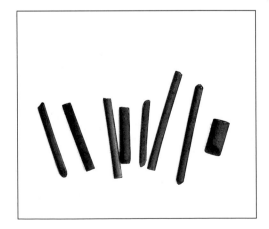

Charcoal is available in sticks as willow or vine charcoal. Both charcoals range from soft to hard and are easy to use to create tones. Charcoal can be messy but produces a velvety, rich, dark tone on the paper. You can sharpen the end into a point with some fine sandpaper or a small sanding pad. You will use a lot of it, as it wears down quickly. Charcoal can be very easily erased, and so it must be made permanent, or "fixed," with a fixative. You can buy fixative in an aerosol form to be sprayed onto the surface of your completed drawing. "Workable fixative" is also available, and as the name suggests, you can spray it onto your drawing and then go back and work into it again. It is therefore not permanent.

Note: *Fixative is extremely harmful to inhale. If you apply it to your drawing, always do so in the open air, and never indoors.*

CONTÉ CRAYONS AND PENCILS

Conté crayons and pencils are available in earth colors. *Sanguine* (red) is probably the most popular color, and a variety of Sanguines are available. Because the pigments are mixed with kolin clay, conté is a hard medium. This makes it somewhat difficult to erase, and so it is not the best medium for a beginner. However, conté is a lovely medium to use—practice and persevere, and you will be rewarded!

White chalk is useful when working with tone to emphasize highlights, and pastels are softer than chalk and bring an element of color into your drawing. You can use them as a basis for adding a tone to your paper (see Chapter 12). Of course, they can also be used as a drawing medium in their own right.

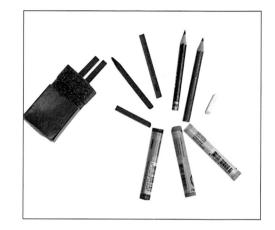

KNEADED ERASER AND CHAMOIS CLOTH

The eraser and the chamois cloth become drawing implements when working with tone. (In Chapter 4, you will learn how the eraser is used to create tone.) The chamois cloth's purpose is to erase large areas of tone, while the kneaded eraser can be manipulated to erase a variety of shapes and sizes. Next to the chamois cloth are some *tortillons*, or "shading stumps," which come in different sizes. They are rolled paper with small to large points on both ends.

When working with charcoal or graphite, you can use tortillons instead of your fingers, as your fingers do not have such small points. They are useful for softening and moving around the charcoal or graphite into very small and precise areas on your paper.

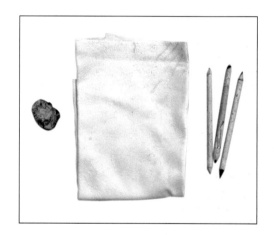

RAZOR KNIFE, PENCIL SHARPENER, AND DRAWING BOARD

There is nothing more annoying than drawing with an uneven, stubby pencil, so make sure that your pencils are sharpened and ready to use. The pencil sharpened with a razor knife is on the left. You can obtain a very long point by carving the wood away. This gives you the ability to not only use the point, but the whole length on the side of the point. The second pencil from the left is sharpened by an ordinary sharpener. The point is a lot shorter, and this is actually the only part of the pencil that you can use to make a mark. Drawing boards are essential to give you a firm foundation. Any hard board will do, as long as it is stable. Here, we have used a piece of Masonite, which is available at your local hardware store. You will need strong clips to attach the paper.

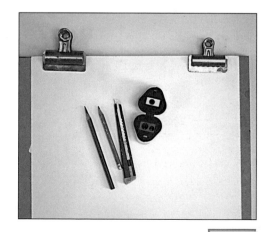

Different Papers

In this section, you'll be introduced to a variety of papers. The surfaces of each paper are demonstrated visually in the photographs. The marks on the papers give you a "feel" for the different textures. However, when you buy your paper, make sure you feel its surface. This helps you to understand how your drawing tool of choice will react to the surface's roughness or smoothness, hardness or softness. The marks shown in these examples are made using (from top to bottom) the side and point/tip of a small piece of charcoal, the side and point/tip of a stick of conté, and the side and point/tip of a graphite pencil.

SKETCH BOOKS AND PAPER ROLLS

You can buy your paper in sketch books or in big rolls of paper. With ring-bound sketch books, it is easier to detach the paper from the ring rather than tear it out of the book. Rolls of paper enable you to determine the exact size of the piece you want. A smooth paper is shown here. There is no interruption from the surface of the paper to disrupt the drawn lines.

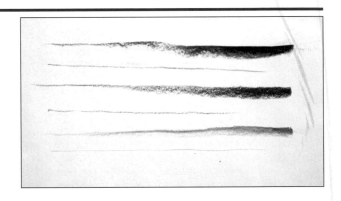

PAPERS WITH SURFACES THAT GRAB OR GLIDE

This paper is rougher. The line does not flow so easily and continuously. Think about the subject matter you are drawing and how it is suited to the surface you are using. If you want to draw a subject with fine detail and the quality of the line is important to you, you should use a smooth paper. If, however, you will not be concentrating on fine detail but an overview of the subject, then a less smooth paper will best suit that need. There are no hard and fast rules; just be aware of the possibilities, and always experiment.

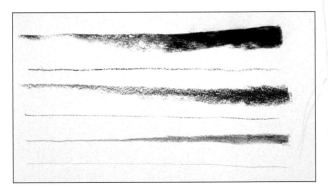

NEWSPRINT PAPER

Newsprint is the most economical paper to use and is available in pads. This is not the best-quality paper, but it is great for practicing. It comes in large sizes and gives you a great sense of freedom while drawing. As you can see from the examples using the side of the tools only, it has a very smooth surface. If this is a drawing that you want to keep, do not use charcoal or pastel, or any other soft medium on this surface.

CHARCOAL PAPER

This is paper that is made for charcoal. It comes in a variety of colors and is not extremely smooth, like newsprint. The texture of the paper grabs hold of the charcoal particles, and so consequently, it retains the charcoal. Notice that the graphite pencil is not such a successful medium on this paper.

WATERCOLOR PAPER

Watercolor paper comes in varying thicknesses. As the name suggests, it is made for watercolor paint. It has a much rougher texture in comparison to the other papers listed in this section. As you can see, the lines created here really reveal the surface of the paper.

PRINTMAKING PAPER

Printmaking paper is excellent for drawing. It comes in different shades of white, cream, and ivory, among other shades. Its beautiful warm or cool shades can emphasize your drawing medium, and so enhance the drawing as a whole.

Lighting is an extremely important aspect of drawing to consider. Drawing is about what you see and how you see your subject. Light is the most important element of drawing because it reveals the structure of an object. Only by accurately drawing the lighting on your subject will you be able to convey a sense of space and dimension.

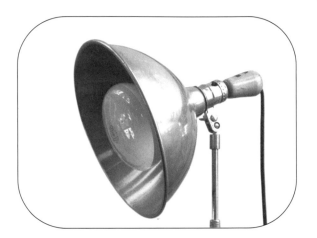

Lighting Sources

ARTIFICIAL LIGHT

When you set up a subject to draw, it is helpful in the beginning to control your light source. The photo on the right shows a jug lit by artificial light. Can you tell what direction the light is coming from, judging by the shadows it is creating? (The answer is at the bottom of this page.)

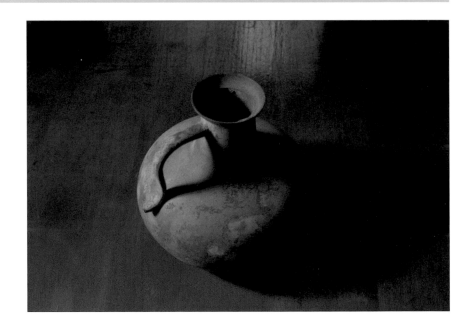

To provide a readily available light source, you can buy an artist studio light that you can easily move around with its lightweight stand. It has a pivoting head so that you can move the light bulb up and down to suit your needs. It is easy to identify the shapes of light and shadow in this setup. The light does not change because it is constant—you control it. Consequently, when you arrange your lighting setup, you control the design element of your drawing. Notice the long shadow to the right of the jug. If you accurately draw the shape of this shadow, you will define the jug because the shadow is an integral part of the jug. It is like putting a puzzle together; every piece interlocks with every other piece.

The lighting source on the jug is coming from the left.

NATURAL LIGHT

Natural light is another term for daylight. It is a beautiful, soft light that gently glides over objects, giving them a softer appearance than that from artificial light. Edges of objects are not sharply defined, as they can be when using artificial light. This lighting creates more subtle and gradual changes in tones on objects. It can therefore be more difficult to render an object with this type of light.

As you gain more experience in your drawing, we encourage you to use natural light. An important point to remember is to light your objects by a window where there is no influence from direct sunlight. This will enable you to work for a longer period, as you will not have to deal with disturbing bands of sunlight or shadows across your paper. Draw from real life and not from photographs. This is simply because you can alter things in life by adjusting the objects to your light source. You cannot change or "investigate" anything in a photograph if you do not fully understand its form or texture. There is no substitute for the real object in front of you.

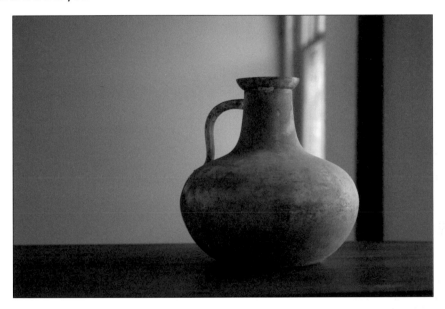

CONTINUED ON NEXT PAGE

LIGHTING AN EASEL

Not only do you have to consider the light on the object you are about to draw, you must also consider the light on your easel. It is an easy factor to forget, but it is important. You have to be able to see clearly what you are drawing. When using natural light, make sure when you begin that your easel is being lit by a north-facing window, as it will provide you with the most constant source of light that is unaffected by the movement of the earth around the sun. The different types of easels available are discussed on page 26.

If you prefer a constant source of light, and have no north facing windows to light your studio, then you must use artificial light. Light your easel as well as you can. Here, the artist has used 4-foot "fluorescent style" daylight temperature tubes. He has angled the light bulbs down toward the easel. The light bulbs in this overhead setup are called *daylight bulbs.* These light bulbs simulate daylight and radiate a cool light, rather than the hot light of ordinary light bulbs. (This is normally a consideration when using color in your work.)

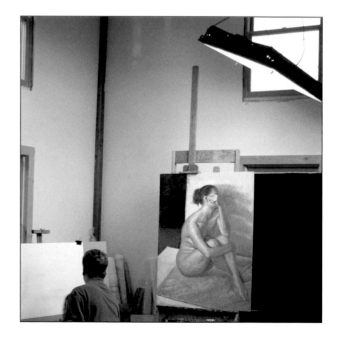

As you draw, you can become very involved in minute and unimportant details, particularly in the early stages of a drawing. Make sure that you have plenty of space to stand back from your drawing and walk around your subject. When you do so, you can judge your drawing objectively.

WALK AROUND YOUR DRAWING

It is very important that you are able to work with space around you. We cannot stress this point enough: You need room to back away from your drawing to review your work from a distance. It will give you a fresh "eye" on your work and also reveal how the drawing is coming together as a whole structure. Good observation is learning to see how everything fits together, not simply how a few parts fit together.

WALK AROUND YOUR SETUP

It is also valuable to have space around your subject matter. It may happen that you do not fully understand, visually or mentally, what is happening with the objects you have set up. If this happens, you need to be able to approach your setup to study it. It is actually impossible to draw something well that you do not understand. This situation probably happens more often when drawing from a model, but it can also occur in other settings.

Never be afraid to really examine your subject as closely as possible. A lack of understanding of your subject cannot be hidden in your drawing, and it will become apparent no matter how you try to hide it. Working from photographs will not allow you this freedom of investigation.

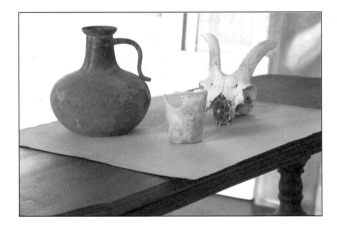

An easel can make your life a lot easier. It is important to have a good support for your work. A table, while providing support, does not give you the chance to stand back and look at your work. It is best to have your work parallel to your eyes, supported on an easel.

FRENCH EASEL

The French easel is one of the most versatile easels, and the one that we recommend. The photo on the left shows an easel with its legs fully extended so that you can stand while you draw. Notice that its legs can be shortened so that you can sit down and draw. The photo on the right shows the easel folded. You can see how compact it is and how easy it is to carry.

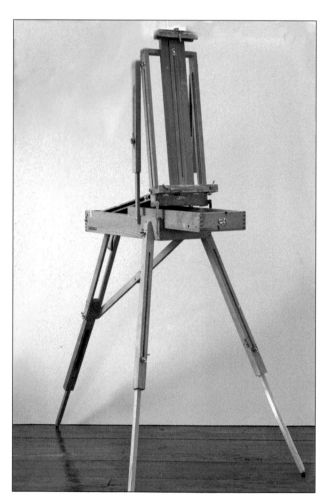
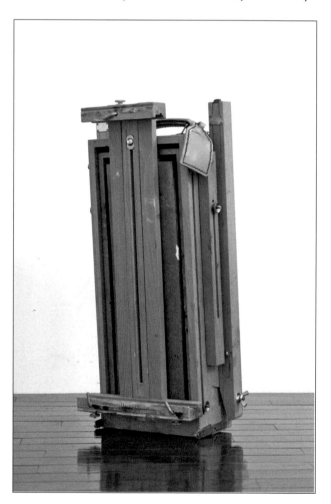

METAL AND WOODEN EASELS

Metal and wooden easels are the cheapest easels to buy. Both have exactly the same design. The legs telescope down to adjust to your height, and a ledge supports your drawing board. You can adjust the angle at which you view your drawing by moving the back leg of the easel closer or farther away from you. These easels are not recommended for outdoor drawing or painting; they collapse easily in windy conditions.

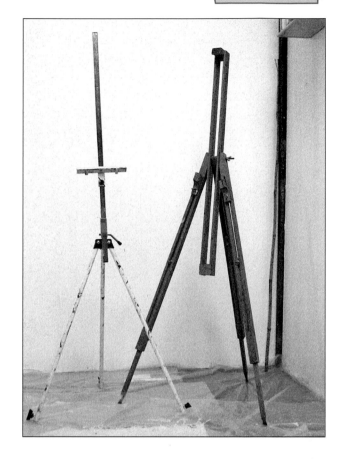

TABLE EASEL

A table easel is exactly the same as a French easel, but it simply comes without legs. It also has a drawer to hold materials. Consequently, it is not as versatile and cannot be used outdoors unless you can find a flat surface to place it on.

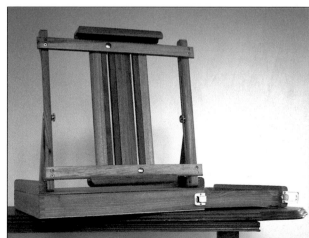

Look at your work in as many different ways as possible. One method is to detach yourself from the drawing so that you can judge it more effectively. Using a mirror will turn your drawing "inside out," and any mistakes, or elements, that you do not want in your drawing will become glaringly obvious. The mirror is useful for checking symmetry, proportion, and measurement. It is also helpful in simply looking at your drawing in a new way.

A Different Angle

This is a complicated drawing. Looking at the drawing through a mirror can offer the artist a fresh look at the work. If there are any glaring mistakes in the drawing, they will become obvious in the mirror image. In this example, the artist wants to check the symmetry of the buildings. It is important to her that the vertical lines are vertical and not slightly angled. It can be difficult to see this when you have been looking at the drawing for a long time. You can also see the drawing's composition (the way you have create your drawing) more objectively because this image in the mirror is unknown to you.

Note: *Another way to see your work in a different light is to turn your drawing upside down. It is up to you to decide which method is better.*

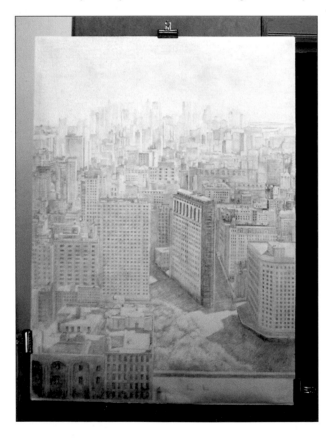 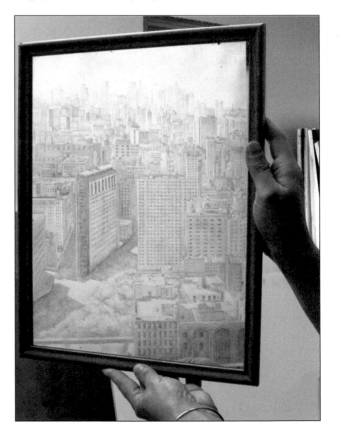

As a beginner, you will want to keep things simple. Don't buy a lot of different drawing materials. It is probably best to concentrate on using one or two drawing media so that you can become proficient with them before you try others. Learning to master one medium, such as graphite, will give you more confidence to use other media. The following are sources for purchasing your art supplies.

IN ART STORES

Going to an art store is a very enjoyable experience because it is exciting to see all of the available materials. As mentioned in Chapter 2, when buying paper, it is better to go to a store and buy it than to buy it online (see below). This way, you can make an informed decision, because you can feel the texture of the paper and determine whether or not it suits your needs.

ON THE WEB

The Internet has made buying art materials very simple. You will find that most bricks-and-mortar art stores also have a Web site like Utrecht (www.utrechtart.com). An online catalog makes it easy to locate what you want and to see everything that is available. Most online stores also deliver. There is often no charge for delivery if you spend over a certain amount of money on materials. You could team up with other artists to make one order to reduce your costs.

chapter

Prepare to Draw

In this chapter, you will be introduced to methods that help you to simplify the process of drawing. You will learn how to light and situate your subject so it will be easier to understand and to draw. You will also be shown a method of drawing that is concerned with drawing shapes rather than lines. This will help you to understand how to draw your subject three-dimensionally on your flat, one-dimensional sheet of paper. Finally, you will consider and look at a variety of marks which can add interest and expression to your drawing.

The subjects that you choose to draw, the way in which you arrange them, and the way in which you choose to light them are very personal choices. In this section, you will be shown different setups as examples only. Be aware that if you don't like the setup, you can rearrange it to suit yourself. The directions given can apply to any situation.

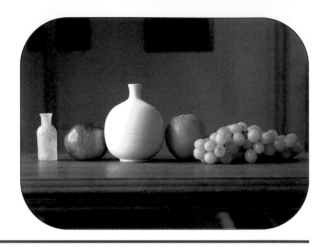

ESTABLISH YOUR EYE LEVEL

Look at the above arrangement. From what angle are you looking at these objects? Think about where the person who took the photograph is standing or sitting in relation to these objects. This is an important consideration because where you sit or stand determines your vantage point. It is very important to maintain the same vantage point when you are drawing. Moving around changes your vantage point, and consequently you have to change your drawing. In the above setup, the person viewing the objects is sitting in front of the table and looking directly at the objects. Notice that you cannot see the tops of the objects. You can see them from the side only. You can also see just a small portion of the tabletop. Notice the height of the back of the table in relation to the objects on the table.

Here are two different eye levels. In the first image (a), you are looking down on the objects. Consider which portions of the objects you can actually see. How much of the table can you see? In the second image (b), your eye level is lower. You cannot see the tops of the objects, and the table is obscuring the bottom of the objects. You cannot see the surface of the table. Remember that what you can see determines what you draw.

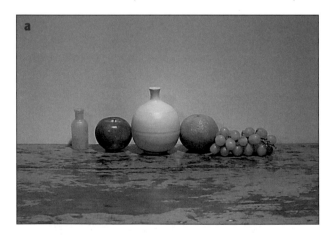

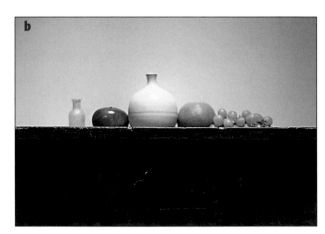

This is a sketch of the objects as they appear in the image (a) at the bottom of the previous page. There is enough surface of the table here to show reflections of the objects on the table's shiny surface. Notice the level of the back of the table, compared to the objects. Determine exactly where this level lines up on the objects. Compare the height of the objects. Measure across to see if the height of the apple and orange are the same. Notice the shape of the tabletop. The strongest light on the largest object is toward the top; this is called the *highlight*. All of the above points are discussed in more detail in Chapter 5. This is an introduction to start you thinking more about what you can actually see, because you cannot draw what you cannot see!

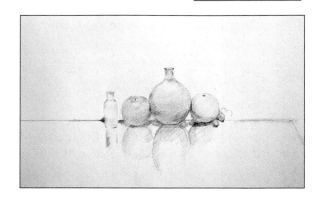

Eye Level: A Quiz

When you look at an object, you do so from a particular point and a particular level. Imagine that your eye level forms a horizontal line in connection to everything you see. To help you, consider the following examples. Where do you think the person who took the photograph was standing? The answers are on the next page.

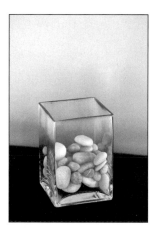

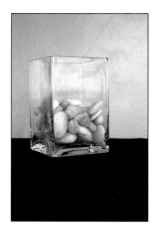

CONTINUED ON NEXT PAGE

Eye-Level Answers

Here the viewer is looking down into the jar; consequently, your eye level is above the jar. Notice that you can still see the pebbles only through the glass; you cannot see them directly from the top, as the viewer is sitting back from the jar, not leaning over the jar.

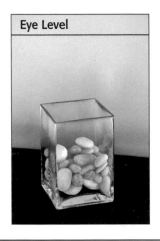

Now, the viewer is looking directly at the jar, just about three-quarters of the way down the jar. You cannot see down into the top of the jar. However, because the jar is made of glass, you can see the back of the jar through the front of it. Notice the bottom left side of the jar, and see how it is arranged at a 45-degree angle. The angle is less vertical, and more horizontal, than the same side of the jar in the previous example.

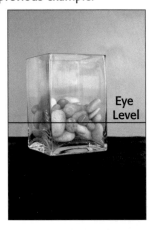

The viewer is looking slightly up at these objects. The table is obscuring your view of the bottom of the objects. You are unable to see the tops of the objects; and they are visible only from the side. A small part of the objects' lids on the left are showing, but they are very small. Notice that the lids are curving down slightly.

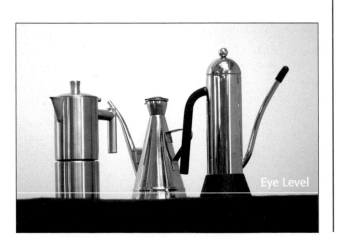

Here the viewer is sitting lower and farther back from the objects. The eye level is lower, the table appears higher, and the bottom portion of the objects is obscured by the table. The curves of the lids are curving down more noticeably than in the previous example. These differences are slight, but keen observation is an important tool for an artist—you must practice it constantly.

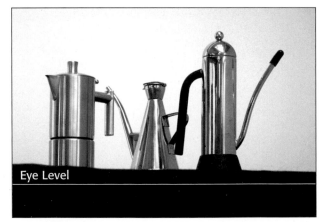

LIGHT YOUR SUBJECT

Lighting is an important factor in drawing. Obviously, it is only with light that you can see and only with light that you can draw. Light reveals the form, or structure, of an object. Here, you consider two different lighting setups.

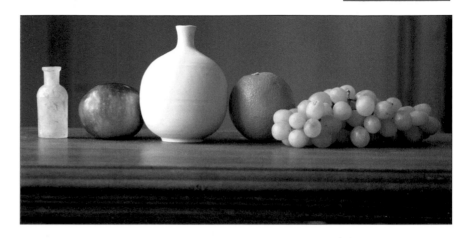

The different types of lighting are discussed in Chapter 3. Now, you can decide on the appropriate lighting for your situation. Here, a spotlight is pointed at the still life setup. It creates a strong sense of light and shadow. This dramatic light is very good for a beginner because each object is defined by its own shadow, as well as shadows from other objects. It is easy to see a jigsaw arrangement of light and shadow when the light is strong.

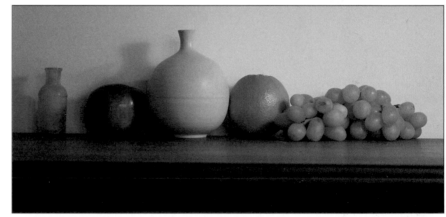

This scene is lit by light coming through a window. As you can see, it is a very soft light that simply filters over the objects. It is a directional light because it is coming through the window. However, the window is a lot larger than the metal frame of the spotlight. Consequently, the light isn't as concentrated as it was in the previous example. This light presents a more difficult situation for a beginner. It is simply not as easy to see the structure of the objects when the light is softer.

Tone Your Paper

Toning your paper is one of the many available methods of drawing. In this section, you will learn how to prepare the surface of your paper to begin the drawing methods that will be introduced in Chapter 5. Descriptions of all of the materials mentioned in this section can be found in Chapter 2.

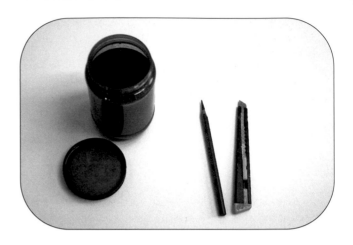

Apply the Tone

Make sure you have an even, flat surface on which to lay your paper. In this preparation, do not use a smooth piece of paper. It is better to use a paper with some texture, or some tooth.

You need the following materials: a razor knife, a 4B or higher-B-number pencil or a graphite stick, and a paper towel. As in the example, you will sharpen your pencil or graphite stick over your paper. Remove the shavings of wood, but leave the shavings of graphite on the paper. Doing so serves two purposes: You obtain graphite to make the tone on the paper, and you sharpen your pencil to a nice, long point. Alternatively, you can buy graphite powder in a jar (shown in the photo above) and simply shake some onto the paper. The powder is more expensive than a graphite stick or pencil and can make a very dark tone, so use it sparingly.

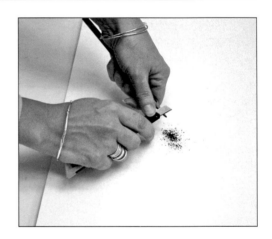

Use your paper towel to smooth the graphite over the paper. If you are using powdered graphite, smooth it in very lightly. Make sure that you obtain an even tone over the whole surface. It is important that you cover the whole page. Do not leave any of the white surface visible.

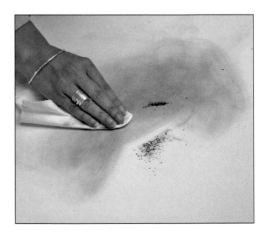

Here is the finished result. The tone has to be workable and not so dense (heavily rubbed in or dark) that it cannot be erased easily. You may find that using a pencil and razor knife enables you to obtain a lighter, more airy tone. Even though it takes more time, you may prefer the tone it gives you. Using the graphite powder gives you a darker and denser tone.

Light tone **Dark tone**

Now you can use a kneaded eraser to test how dense the tone is on your paper. Erase a small area. It should be easy to erase the tone so that you can see the white surface of the paper. If it is difficult to erase, you probably rubbed the graphite into the paper rather than smoothing it over the surface.

In this quick sketch, the artist used an eraser to take away the large shape of the model's belly. Because the chest was also being lit, tone was erased in strokes rather than in shapes. The artist wanted the light to be a little more subdued on the chest than on the belly.

In the next section, you will learn that using your eraser to make marks rather than large shapes can add even more variety of tone to your work.

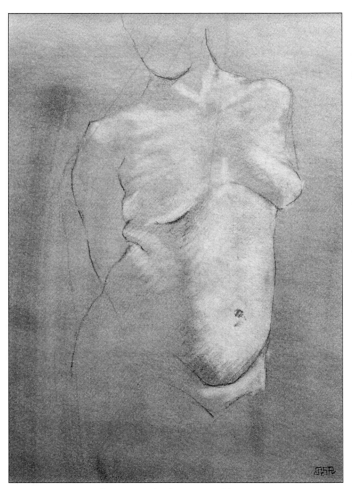

Figure Study, *by J. S. Robinson*

Make Your Marks

A drawing holds the viewer's interest because of the marks that were used in its creation. As you gain more experience drawing, you will notice that there may be a preponderance of certain marks in your work. These marks will come to characterize your style and make the work individually yours.

Marks of Spontaneity

In this drawing, the model has taken a pose that will last for only a few minutes. The artist had to work quickly to relay the information in front of him onto his paper. In this exercise, intuition and spontaneity come into play. Consequent on having a short time to work, the marks are more energetic. Notice that the lines drawn are used to convey a general sense of shape and not to delineate any details. The lightness of the marks gives the drawing a gentle quality. The fluidity of the lines reinforces the curvature of the whole pose. The transition from light to darker marks relates to the action of bending over. The darker marks and the marks of the shaded areas are located within the closed, curved area of the body.

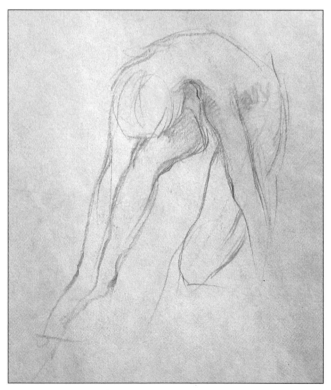

Kneeling, Quick Study, *by Dean Fisher*

This drawing is a spontaneous response to a figure in motion. The weight of the body is carried by the left leg, but is about to be transferred to the right leg. This motion is skillfully realized by the almost continuous angled, dark, and thick mark along the torso and on the left side of the body. There is no one continuous line in this figure; rather, the line is broken into different marks, which nicely convey the sense of action. The marks arching out from the left leg reinforce this impression of a forward motion.

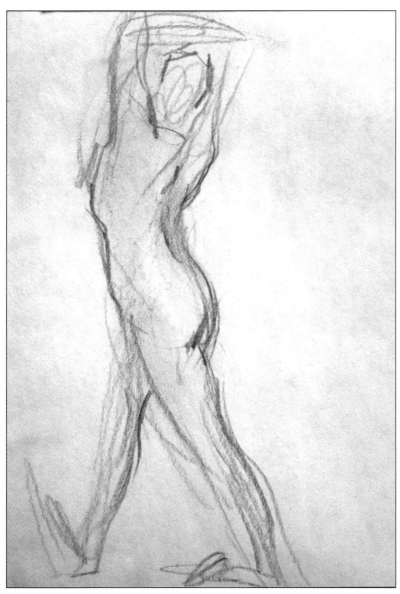

Striding Figure, Quick Study, *by Dean Fisher*

Look at the variety of marks made in these four examples. The paper and hardness of the pencil are given under each illustration. The completed drawings are on pages 42–43.

Smooth sketching paper and a 4B pencil

Smooth sketching paper and a 4B pencil

Smooth sketching paper and a 2H pencil

Smooth sketching paper and a 4B pencil

Smooth sketching paper and a 2H pencil

Smooth sketching paper and an H pencil

Smooth sketching paper and a 4B pencil

Smooth sketching paper and an H pencil

CONTINUED ON NEXT PAGE

All of the marks made with a 4B pencil are used in this drawing. The softness of the pencil gives this drawing an airy quality. The static quality of the pose has been interrupted by the energy of the line.

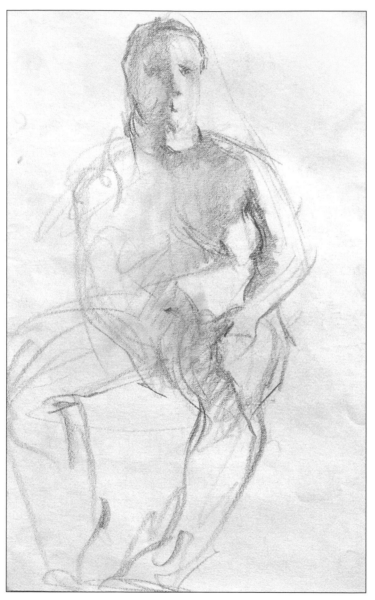

Seated Figure, Quick Study, *by Dean Fisher*

All the marks made with a 2H and H pencil can be found in this drawing. The details of the face have been given more attention, as they have been finely delineated with careful lines and marks.

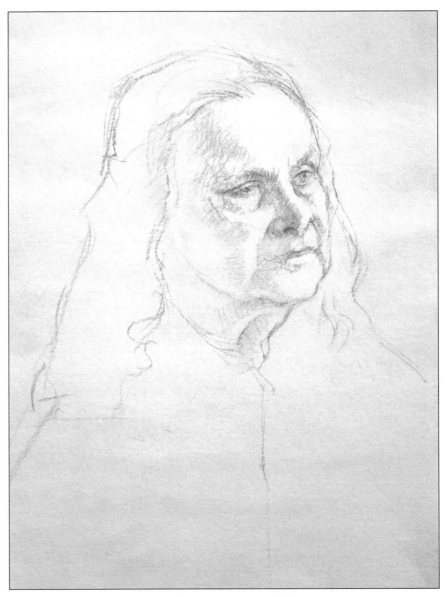

Portrait Study, *by Dean Fisher*

Before you begin to draw, you need to determine the correct proportions of the object you are going to draw. In this section, you will learn to use a simple tool as a visual measuring aid.

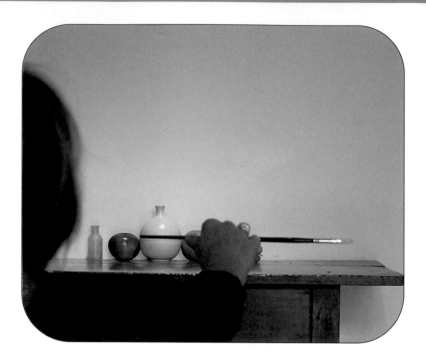

The Process

When you measure your subject, it is essential that you either sit or stand in a fixed position. You must also maintain the same position that you intend to have for your complete drawing (see page 32).

Holding an implement with a long handle (such as a paintbrush, a knitting needle, or a long pencil) as a measuring tool, extend your arm completely. Align the end of your measuring tool with the top end of the object (in this example, a vase) and then use your thumb to mark the position of the bottom of the object on your measuring tool. You have now created a unit of measurement, or a *scale*, that represents the height of the object as seen from where you are sitting or standing. To record this measurement for later reference, you can put some tape (opaque, not clear) around the measuring tool to mark this point, which is shown in the photo on the right. You can then hold the tool horizontally (arm straight) to line up the end of the tool with the left side of the vase. You can see where the tape ends. Now you have established the relationship of the height of the object compared to its width.

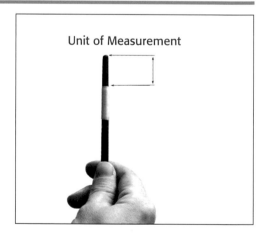

Unit of Measurement

To the right is a diagram showing two different ways to measure the height and width of the vase. The unit of measurement, denoted by black lines, compares the height of the vase to its width. Note that, as a comparison, the measurement of the width of the vase only reaches to the bottom of the neck, vertically, on the vase.

The red lines denote a measuring scale, using the width of the vase's spout. Note that the height of the vase is four-and-one-half times the width of the spout. When you draw, you can plan out the proportions of your subject with this information. This plan lets you achieve the right shape and proportion.

Of course, you can designate any portion of the vase as the unit of measurement. To maintain consistent measurements, always have your arm fully extended, not bent at the elbow, and maintain the same standing or sitting position each time you measure your subject.

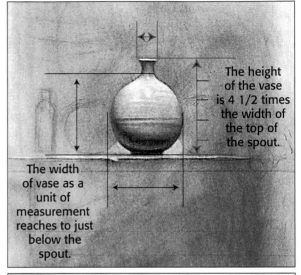

The height of the vase is 4 1/2 times the width of the top of the spout.

The width of vase as a unit of measurement reaches to just below the spout.

This figure drawing shows you an example of how this technique can work in different situations. Here the length of the head, from the top of the hair to the bottom of the chin, has been used to determine the height of the figure.

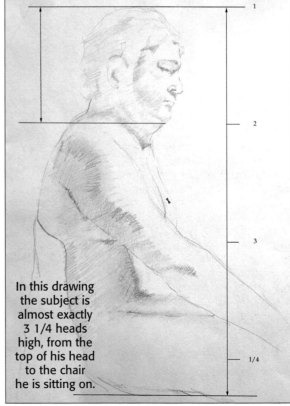

In this drawing the subject is almost exactly 3 1/4 heads high, from the top of his head to the chair he is sitting on.

Figure Study, *by J. S. Robinson*

Find the Angles

Correctly measuring your objects is only one part of drawing exactly what you see in front of you. You also have to consider the angles of the contours of objects. Doing so can be tricky, but there are methods that you can use to determine these angles. The method shown here is a simple one.

Look for the Angles

With the same measuring tool that you used previously to determine a scale, you can also find the angles of objects that are not horizontal or vertical. Fix your position and extend your arm straight out. Hold your tool in front of the curve, or angled contour, of the object you will be drawing. You can either remember the angle and add it to your drawing (visualizing it with your measuring tool can help you remember it), or you can transfer the measuring tool to the correct position on your drawing paper by keeping the tool in the same position and marking the angle directly from your tool onto the paper.

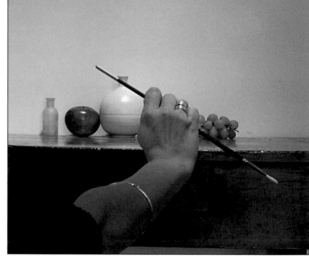

Look at the curved form, and you can see two or three angles, representing various aspects of the curve. You can then lightly draw these angles on your paper. Doing so will assist you in finding the exact shape of the curve.

When you try to represent a more complex contour or form, draw multiple straight lines to represent each section of the shape that you have observed with your measuring tool. You can repeat this process as many times as you feel is necessary. It helps you to see the objects that you draw more clearly. You will be surprised at how much easier it is to record difficult shapes if you use this method. Feel free to lightly draw these straight lines on your drawing to use as a guide. You can also leave them on your drawing. Some artists, such as Euan Uglow and his teacher William Coldstream, left guidelines on their drawings or paintings in the form of lines or tiny crosses. They felt no need to remove them, and, in turn, these marks became a part of the work.

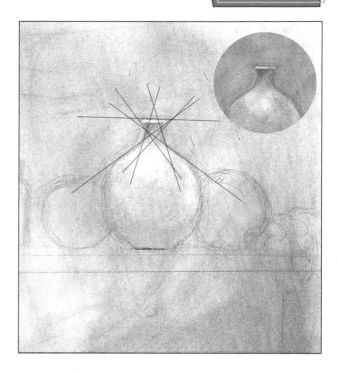

Discover the Pattern of Light and Shadow

In this chapter, you will learn very simple ways of establishing the shape of light and shadow areas in your drawings. You will also learn how to achieve the illusion of three-dimensionality. The techniques in this chapter are used to create a *reductive* or *tonal* drawing, as the shape or pattern of light is removed from previously toned paper. A beautiful oval-shaped vase is used for many of the drawing examples because it has a simple round form, which lends itself well to the principles being demonstrated here.

See the Value of Squinting

Squinting, which is easy to do, is an important technique that helps you to view your subject in simplified shapes. Look at the picture on the right. We have purposely blurred the image to show you how details are no longer clearly visible. They become blurred, and you can see only large forms. If you squint at the image, it should become even more simplified.

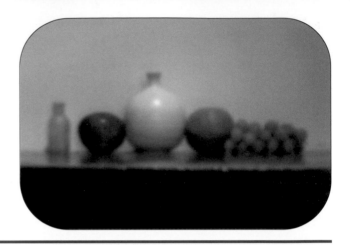

In the initial stages of your drawings, try squinting as often as possible when you're looking at your subject. Eventually, squinting will become second nature to you. The reason for doing this is to concentrate your attention on the large shapes. Many beginners become overwhelmed by details, and details are not important in the first stage of a drawing. What is important is to map in the structure of what you are drawing. You will not find structure in details. The level of realism you achieve in your drawing is based on analyzing and drawing the structure of your scene or objects.

The painting here demonstrates how large shapes are an integral part of the work. Notice how the artist here uses just three large main shapes to define a young girl looking down: the side of the face, the head of hair, and the side of the body. Within the large shape of the head, there are three or four smaller shapes that define different sections of light on the hair. You can also find smaller shapes within the other two larger shapes. Basically, there is really no detail, and yet you can tell what the object is right away.

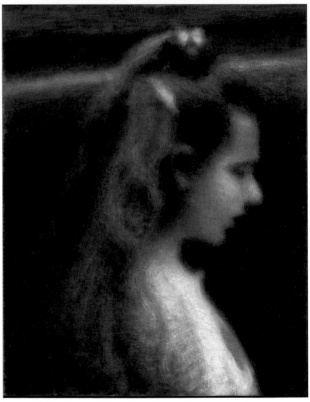

Lakewood, *by Tim Lowly, courtesy of the artist*

Squint at the image on the right. How many large shapes do you see? Do you see four large shapes of shadow? There is a large rectangle of shadow in the lower half of the image. There is a definite triangular-shaped shadow in the top-right corner. There is also a lighter rectangular shape of shadow joining the triangular shape to the rectangular shape in the lower half of the image. The bottom halves of four of the objects (with the bunch of grapes as one object) are all in shadow. This shadow is punctuated by triangles of light.

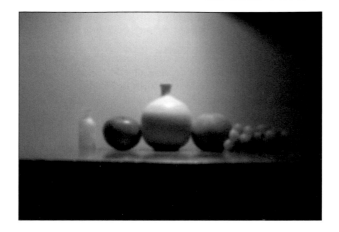

In this piece, the artist has drawn in the shapes as she sees them. In doing so, she has simplified the information that her eye is receiving. She has eliminated the details and concentrated on connecting the shapes of shadows together. The subject matter has been observed as a completed jigsaw puzzle. The pieces of the puzzle are comprised of the shapes of light and shadow, which fit together from the darkest shadow to the lightest highlights.

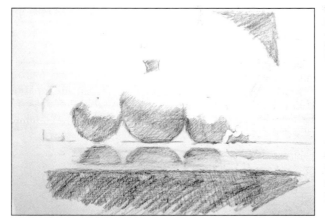

Still Life Study, *by J. S. Robinson*

Here is the same subject as above, but the lighting has changed. Take a good look at this image and decide what shapes you can see in this jigsaw puzzle of light and shadow. When you think you can see the large shapes of shadow, make a sketch of these shapes. You can either outline the shapes that you see or simply fill in the shapes with a light or dark tone. We discuss tone on page 53. Keep it loose; it doesn't have to be exact. Over the next page you can see the sketches that the artist has made of this image.

CONTINUED ON NEXT PAGE

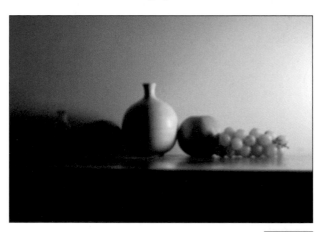

Tone: From Dark to Light

The images in this section will help you identify the many varied tones of gray that can be found in a drawing.

Here is a tonal sketch of a woman's head. The tone on the paper has been erased to reveal the light on the woman's head and neck. Look closely and you will see that within that area of light, there are tonal variations. In the large shadow area on the left of the head, there is also a large variation of grays down to black.

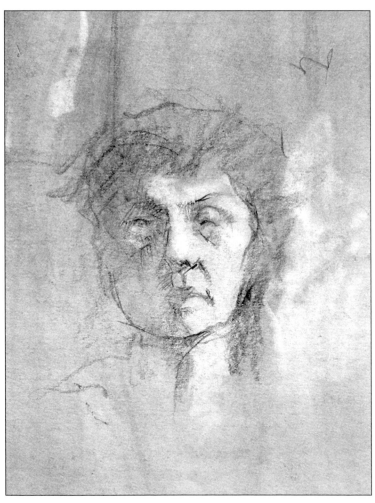

Head Study, *by Dean Fisher*

Now the image has ten different tones circled. These tones range from the brightest (white) to the darkest (black) on the head. Some of these transitions can be very subtle. The more variation of tone you use, the higher the level of accuracy you will achieve in your representational drawing.

The ten different tones are identified in ascending order from lightest to darkest in this image, with lightest being 1 to the darkest being 10. Can you see the range of gray shades that you can obtain from your graphite pencil? The lightest area can be seen on the tip of the nose. A nose usually displays the lightest area of tone, as it is the one feature that sticks out farthest from the face. Consequently, it is closest to the light source. The inner corner of the mouth is receiving the least amount of light, so a dark tone is used there. The darkest area of the face is located in the nostril. This area receives the least amount of light on the face, as the light cannot enter enough of this space to light it up.

Notice that the artist has also drawn out the shapes around the eye in the light. While squinting, he saw two large shapes of shadow: one shape at the outer corner of the eye and one shape at the inner corner of the eye.

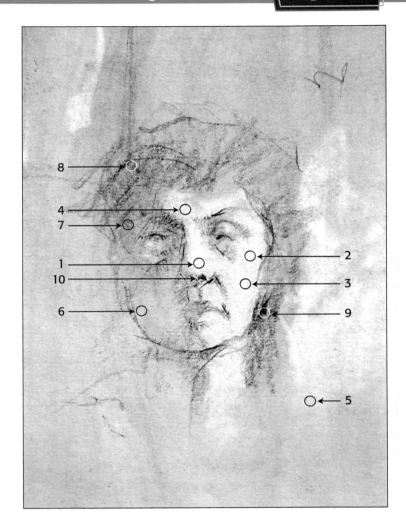

You can draw a beautifully round, solid object by following the directions given here. Be sure that you have read and understood the previous sections in this chapter. You will need to understand the terms used in the previous sections in order to complete the drawing.

Artists refer to an arrangement of objects as a *still life* because the objects do not and cannot move unless someone moves them. Consequently, you can be sure that if you do not finish your drawing in one session, you can return to it at any time, knowing that it hasn't changed.

Try to set up your own still life by choosing any round object that you would like to draw—for example, an apple, orange, or white ball. Use a spotlight on your object (see page 35). Place the light to the right and above your still life. Use the same vantage point that is shown here. You will probably need to sit down to get this vantage point. Make sure that you have a tone on your piece of drawing paper (see page 36), and that you secure the paper to a board. After the board is mounted on your easel, you are ready to begin.

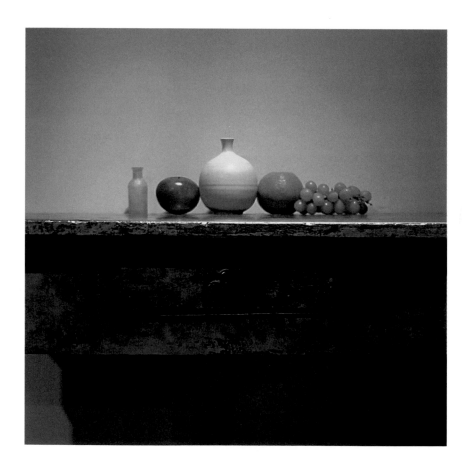

Map out the shape of your object. Don't worry about obtaining a perfect outline of your object. This is not necessary. Draw several lines if you have to, and keep them light so they do not distract you. Be aware of the proportions of the object. Remember to measure. If you cannot accurately draw the curve of your object, refer to "Measure Your Object" in Chapter 4.

To key your drawing means to create a tonal range in your drawing. Tonal relationships (see pages 54–55) show you how the lightness or darkness of one area relates to the lightness or darkness of other areas in your subject. This development of tonal relationships is essential to building the illusion of space and form in a drawing.

Squint and Observe

While looking and squinting at your entire still life setup, determine where the lightest light and the darkest dark are (see page 55). The lightest light usually appears on the lightest or most reflective object that is closest to the light source. The darkest dark usually appears in the area that is farthest from the light source, such as a crevice or under the object (as in the still life). If you find it difficult to see the lightest light or darkest dark with your eye alone, consider where the light is coming from and which portion of the object it is shining on. Also consider the texture of the object receiving the light.

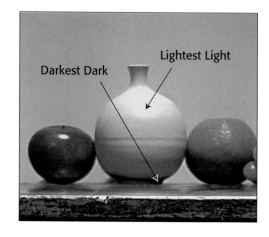

Once you have determined where the lightest light and darkest dark are, indicate them on your drawing. With your eraser, erase the shape of the lightest light area. With a 4B pencil (or higher B number), draw the shape of the darkest dark area. Don't press too hard on the pencil. You may want to refine this shape later, or you may want to make it a little lighter later on. Now that you have two reference points, form a scale from lightest to darkest with which to compare all of the other areas of tone in your object or objects (see page 53). If you are using more than one object, you will still choose only one area for the lightest light, as you are establishing only one tonal scale for the whole drawing. If you see a tone in the light area that isn't quite as bright as your lightest light, you can observe to what degree that area is darker than your lightest light.

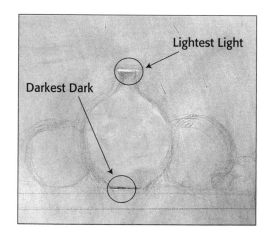

A helpful technique to aid your eye in establishing the scale of your tones is to use a peephole.

Help Your Eye to See

Peepholes are easy to make. Take a square piece of cardboard and punch a small hole through it. Look through the hole with one eye to isolate various areas in your subject. You can make comparisons between tones that you are unsure of. The peephole concentrates exactly on a small area. Your eye will therefore see only what is necessary and will not be influenced by all of the other tones in that area.

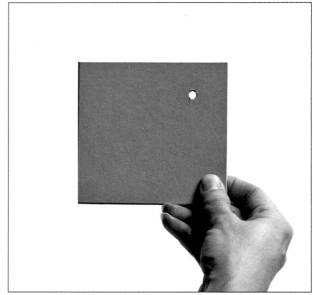

If by chance you forget to bring your peephole tool with you, you can always create one with your hand, as demonstrated in the photo. This method is helpful when you just can't determine how light or dark any given area is next to another area. You can also use this method to double-check your sight, as there are often surprises in the world of tonal relationships.

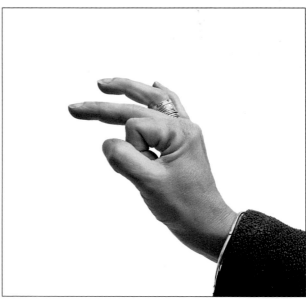

You have now established your lightest light and your darkest dark. You have also mapped out with lines the shape of your main shadow area.

You are now ready to develop the tonal range of your object in order to achieve a three-dimensional object. Make sure that you have a 4B pencil and a kneaded eraser.

Erase and Add, Making Shapes

The light on the still life setup is hitting roughly the top quarter of the vase. To achieve a lighter light area, you need to take an eraser and gently erase the shape of the large lit area. Do not erase too much. This area should not be lighter than the lightest light. You need to create a tone that does not conflict with the lightest light. If you do not make this tone slightly darker than the lightest light, the illusion of light, and therefore the illusion of form, will be destroyed.

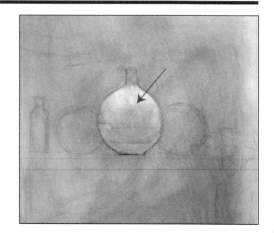

In this image, the artist is indicating the top lip of the vase. The artist erased the shape that is catching the light. Again, do not make this area lighter than the lightest light or highlight. Check your proportions, and make sure the height of your object is proportional to its width. (See "Measure Your Object" in Chapter 4.)

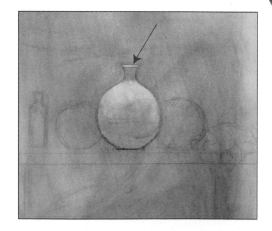

To further emphasize the light on the top half of the vase, the artist added more tone to the area around the outside of the top half of the vase. He used a 4B pencil to add more tone onto the paper. This facilitates the illusion of the lit area of the vase coming forward and "popping out" at us.

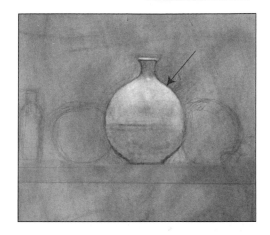

In this image, the artist added more tone again, but this time he added a shape to suggest the shadow area at the bottom of the vase. The tone of this shadow is not darker than the darkest dark. By making the tone slightly lighter than the darkest dark, the artist has enabled the bottom half of the vase to come forward. If the tone was the same as the darkest dark, the vase would appear flat and, consequently, have no form.

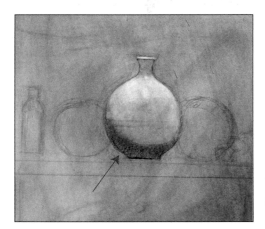

The shape of shadow was lengthened on the left side of the vase. This tone is very close to the tone used at the bottom of the vase.

CONTINUED ON NEXT PAGE

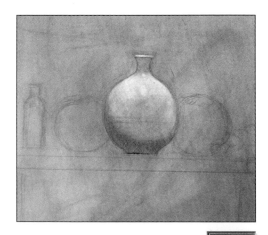

The short neck of the vase is more fully formed with the addition of shapes of darker tone to the sides of the neck of the vase (as shown here). These shapes on either side of the neck seem roughly triangular. When you add tone with your pencil, keep the edges soft. Do not use a line of any sort to suggest the end of the shadow area. If you do, you will flatten out the form and will not be able to achieve the roundness of the form.

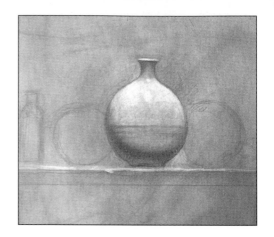

The middle of the neck of the vase was also in shadow. This was not a deep shadow but was certainly a darker tone than any tone in the light area. Therefore, a soft tone was added to the tone that was already on the paper. While the artist added the tone, he kept standing away from his drawing to check all of the tones at a distance. This is very important. If you do this often, you can see and correct mistakes before they become very large mistakes!

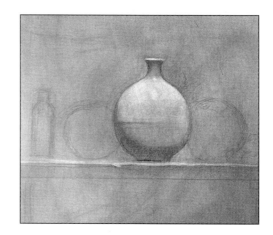

The Half Tones

The artist noticed that the light area of the vase gradually darkens as it approaches the shadow area. This darker area within the light area is called the *half tone*. Careful observation and rendering of the half tone is crucial to successfully render the vase's volume. The quality of this half tone will describe whether the form turns gradually or abruptly. As more graphite was added, the artist used a tortillon (see page 17) and his finger to smooth out the transition from one tone to the next.

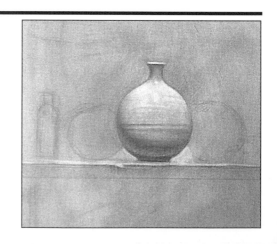

For larger areas, you can use a chamois cloth or paper towel. If you use your finger, make sure your hands are clean; otherwise, your skin's natural oils will mix with the graphite, making it difficult to remove later. Graphite has been erased in rough triangular shapes around the outer edges of the vase to emphasize the shadow on the bottom of the vase and to prepare for the rendition of the other objects.

Observe the object at its edge. As the form turns toward the edge of the object in the light area, notice that the tone of that area begins to get slightly darker. This is difficult to distinguish, as it is often a very subtle change of tone. The addition of these shapes of slightly darker tones will help the form turn, which adds volume to the object you are drawing. These darker shapes of tones within the light area are referred to as the *light half tones*. Remember that the light half tones cannot be as dark, or even get close to being as dark, as any tone within the shadow.

Note: *To erase small areas, shape your kneaded eraser into a point.*

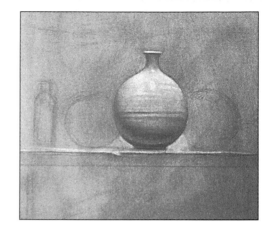

The artist continued to develop the drawing, observing all areas in relationship to each other. Notice how the light on the wall begins to show a gradation of tone that indicates the direction of the light. The shape of the light on the table further enhances the direction and quality of the light, by defining the shape of the shadows of the objects sitting on it. (See the final stage of the drawing on page 65).

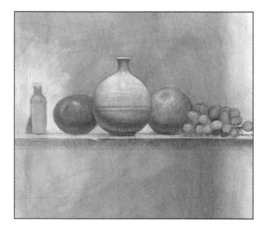

TIP

Keep your kneaded eraser clean by continually kneading it! If you don't keep turning the eraser in on itself, it will not be able to erase more graphite, as the surface will already be overloaded with too much graphite. Keep finding a new surface to use.

Reflected Light

The reflected light is the area of the shadow on an object that is lighter than the darkest part of the shadow. This lighter area within the shadow receives more light because the shape of the form in that area turns in a particular way or begins to face a new direction, and so can be influenced by light that is bouncing off other nearby forms or surfaces. The reflected light may also be caused by a secondary light source.

Dean, as an art instructor, has a saying that he finds himself often repeating to his students: "Don't fall in love with the reflected lights!" The reason for saying this is because many students tend to overmodel or overstate the lightness of the reflected light by making it as light as, or lighter than, the tones in the lit part of the form.

The most likely reason for this overstatement of lightness is the tendency to focus only on the tones within the shadow and not consider the shadow in relation to the light part of the form. The result of overmodeling a form is that instead of enhancing the volume of the form, it does the opposite and flattens it out. It is an understandable phenomenon. In the quest to heighten the three-dimensionality of objects, we try to use all of the devices at our disposal to create the illusion of reality. We see that seductive reflected light in the shadow, and we "run" with it. This is an example of why it is so important, when looking at your subject, to try not to look "into" one small area, but to compare a given area against all of the other areas of your drawing in order to create a scale of tonal relationships. This will render convincing light, form, and space in your work. Look at drawings by great masters. You will see how they understate the reflected light.

The detail above illustrates the use of reflected light on all three objects—apple, vase, and orange—from the still life used as a previous example. Notice how the reflected light helps give the illusion of the form turning away from the viewer, thus enhancing its voluminous quality.

In the portrait, the reflected light is functioning in a similar manner. It allows the center of the face, where the features are, to come forward, while the reflected light in the shadow recedes spatially. Notice that the tone of the reflected light is substantially darker than the tones on the light side of the form. The use of reflected light also adds a transparency to the shadow.

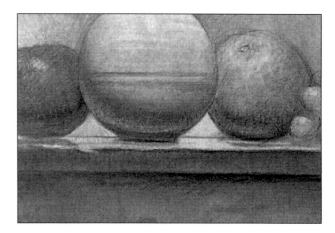

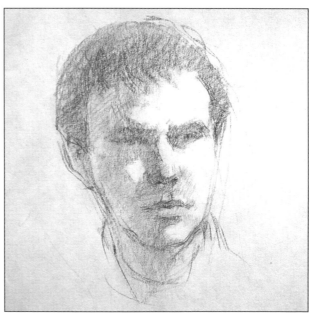

Head Study, *by Dean Fisher*

The feeling of the *texture* of a material is achieved in large part through the fine-tuning of the multitude of tonal relationships in the drawing. We will refer to these differences as *nuances*.

The final stages of your drawing will entail carefully observing the small variations in the topography of your objects. These variations could include details such as the subtle ridges in the vase, the uneven edge of the table, the bumps in the peel of the orange, or the nicks and dents in the antique table. The rendering of such features will add clarity to your drawing and enhance the feeling of reality in your work.

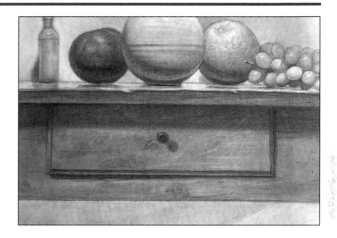

In this final stage of the drawing, the shadow on the wall and the shadow underneath the ledge of the table are now more fully rendered. Notice how airy the shadow appears under the table ledge. You can achieve this quality only by carefully controlling the value of your tones. Further attention to crispness or softness of edges between objects helps to add realism to the image.

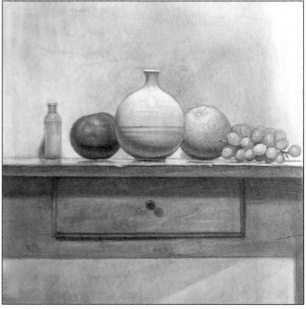

Arrangement in Graphite, *by Dean Fisher*

Energy and drama define this drawing. There is a tremendous sculptural quality which is achieved through a strong contrast of tone and a vigorous application of the charcoal. Notice the great economy of means used to render the figure.

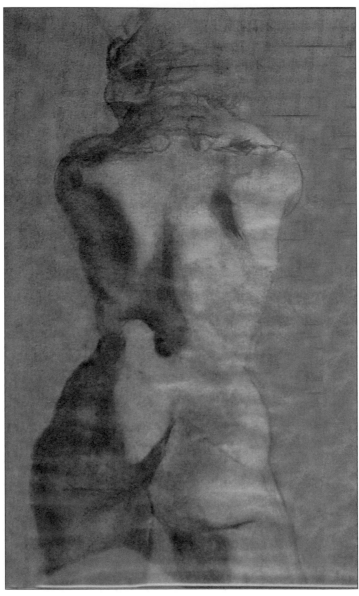

Figure Study, *by Kenneth Pace, courtesy of the artist*

In this drawing, the range of tone is quite small. The artist used only about 40 percent of the tonal scale (from white to black). The minimal use of contrast suggests the very round large mass of the back. There are no sharp angles or bony protruberances here. The few lines used can hardly contain the volume of the figure.

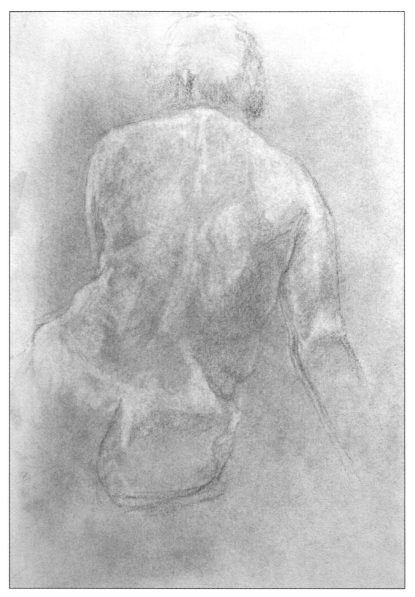

Seated Figure, *by J. S. Robinson*

CONTINUED ON NEXT PAGE

Gallery: Examples of Light and Shadow (continued)

In this drawing, there is a strong feeling of mystery that is achieved through an extensive use of shadow. The area that falls in shadow comprises about 80 percent of the drawing. Within the shadow area, there are interesting shapes and spaces that act as a lure to pull the viewer in. The dark shadows also act as an excellent foil to the glaring light on the rooftop, giving a great deal of visual impact to this drawing.

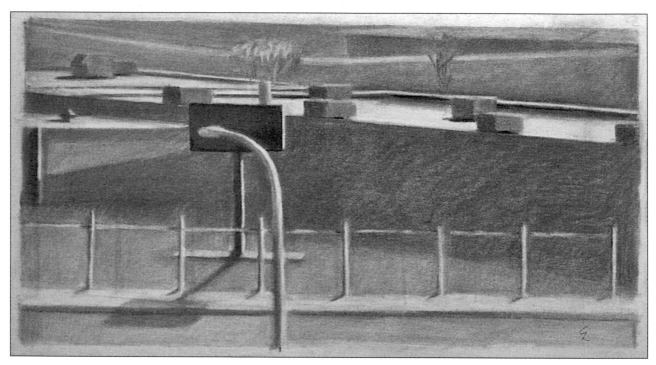

Street Scene, *by Constance Lapalombara, courtesy of the artist*

In this strongly patterned drawing, the white of the paper and the darkness of the charcoal are used extensively to maximize visual impact. The feeling of direct sunlight blasting through a window and hitting the chairs creates a powerful interplay between the light and shadow.

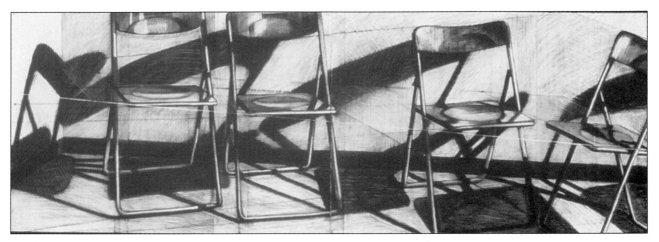

Chairs #2 *by Eileen Eder, courtesy of the artist*

CONTINUED ON NEXT PAGE

This drawing shows a corner of a room being lit by natural light through a window. The light sifts gently over the objects and casts soft shadows. There is a shape of darker tone, running under the sink and the countertop, and in the left side of the sink. The darkest area defines the separation of the sink and the countertop. The artist has kept his shadows light to impart the sense of daylight filtering into every object and onto every surface.

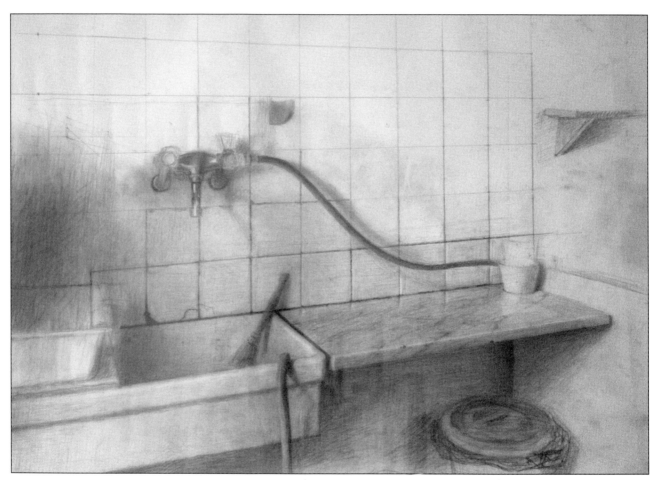

Kitchen Sink, *by Richard Maury, courtesy of Claire Maury and Forum Gallery, New York, NY*

This drawing also uses natural light to reveal form. There is more than one light source in this drawing. There is a wide range of tones. The artist has used his tones extensively to suggest the form of the figure, the textures of different objects in the room, as well as the room itself (including the walls and floor). All of these elements receive the light in a different manner, which creates a large variation in the tonal scale.

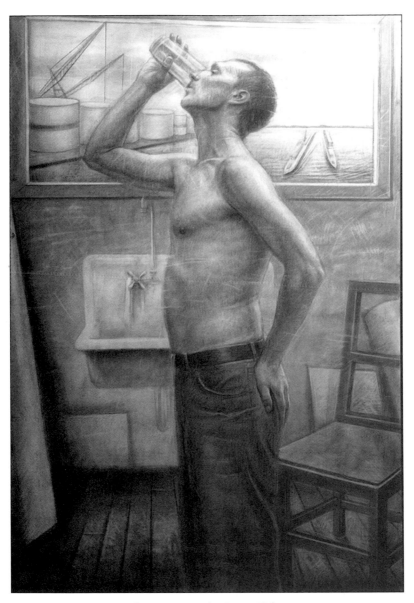

Figure at Rest, *by Dean Fisher*

6

Introduction to One-Point Perspective

Two Florentine architects, Leon Battista Alberti and Filippo Brunelleschi, first formulated mathematical systems of perspective in the fifteenth century. This enabled the artists of that era and onward to represent a recognizable three-dimensional world on a flat surface. This chapter will teach you some basic rules of one-point perspective.

What Is One-Point Perspective?

When drawing, the laws of perspective apply to everything that you look at. In one-point perspective, the front of an object is parallel to your plane of vision. This means that the object is directly facing you. There are several examples in this chapter to illustrate this point, beginning with a classic example of train tracks.

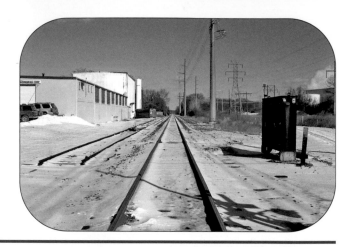

This example of one-point perspective shows train tracks disappearing into the distance. You can immediately comprehend this scene as indicative of distance because the train tracks become narrow. The distance between them becomes so small that the tracks appear to meet. This doesn't really happen in life; however, it is what the human eye sees. The point where the tracks appear to meet indicates where the viewer is standing in the scene and is referred to as the *vantage point* (or *viewer point*).

When you look at train tracks, you see that the sides of the tracks converge. In perspective rules, the point where the two sides meet is called the *vanishing point*. The height from the ground to your eyes is called the *eye level* (or *horizon line*). Notice that this point is at the exact height of your eyes, neither above nor below them. You look at everything in this world from the height of your own eye level. Everyone has a different eye level except for people who are the same height!

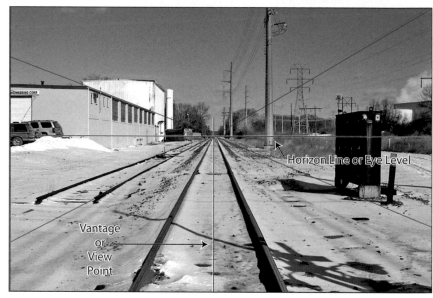

The photo above has a superimposed diagram of black lines to indicate the horizon line or eye level. The vanishing point is where the vantage point and the horizon line meet. The red lines indicate how all of the sides of the buildings, the train tracks, the telephone poles, and any object that is perpendicular to the horizon line converge at the vanishing point. Another way to describe this phenomenon is that all parallel lines converge in the distance at the vanishing point. Notice that the vertical lines remain vertical.

This is a demonstration of the *field of vision* (also referred to as the *cone of vision*). The viewer is positioned in the center of the photograph. His eye level forms the horizon line in the photograph, and he is transparent, so that you are able to see the vanishing point through his head. The vanishing point remains constant as long as he stays in the same position. If he moves to the left or the right, even slightly, the vanishing point changes. His eye level, of course, remains the same, as he cannot change his height.

The figure in profile is the same person of the same height. He is standing on an artificial line on the ground, which is referred to as the *ground plane.* Notice that as he is placed farther into the distance, he becomes smaller. However, his eye level remains fixed at the horizon line because his eye level is identical to the viewer's eye level.

If you take a strip of wood with the same height as your eye level and place it anywhere—some distance away from you—you will notice that the top of the stick always remains on the horizon line.

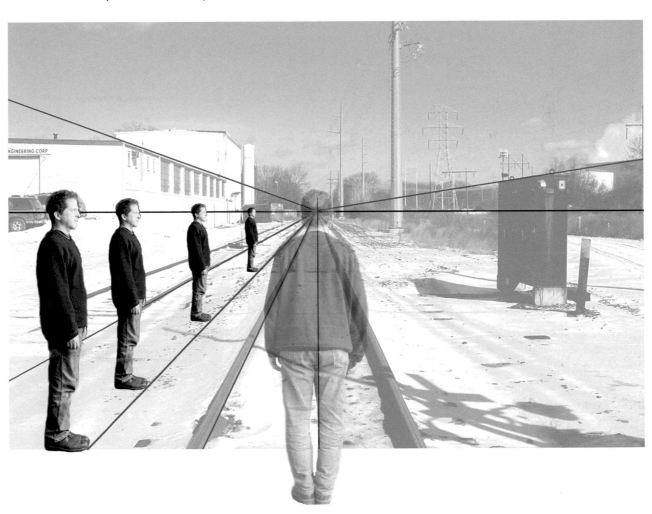

Keep an eye open for your own examples of perspective. The more you look for and study these ideas, the more coherent they will become. Try to determine where the vanishing point and the horizon line are in the following examples.

Scenes of Everyday Life

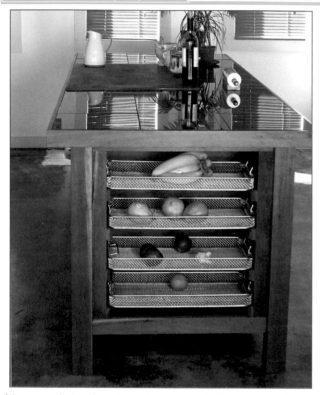

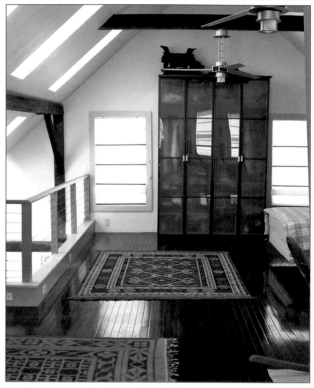

This example is taken from the authors' kitchen. The photographer is standing in front of the island, looking down. Consequently, the eye level of the photographer is above the island.

Note: *The eye level does not change, even though he is looking down. (See "Establish Your Eye Level" on page 32.)*

Look at the sides of the island. They are converging quite dramatically to a vanishing point, just like the train tracks. The vantage point is located at the height of the eye level of the person who took this photograph. Can you accurately pinpoint the horizon line and the vanishing point? Look at the baskets holding the fruit; the sides of these objects are also converging, as their sides are parallel to the sides of the island. As the baskets move down in the stack, below the eye level of the view, you can see more of the top of each one.

Rule: *All parallel lines converge to the same vanishing point.*

Here, the rugs on the floor, the top lines of the skylights, and the banister all meet at the same vanishing point because all of these lines are parallel to each other. Can you tell where the vanishing point is? Realizing where the vanishing point is allows you to draw the correct angle on the sides of your objects, making them decrease in size. This gives a sense of three dimensions to your drawings.

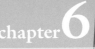

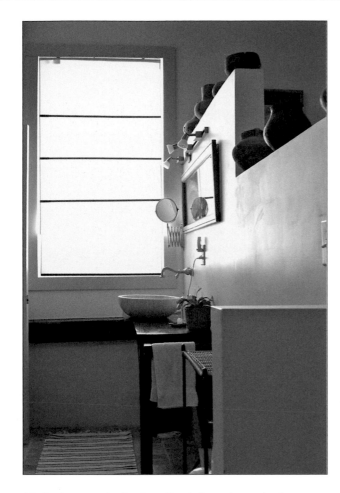

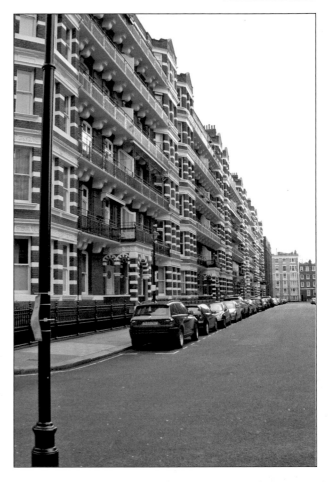

In this bathroom, the horizon line is just above the bottom ledge of the window. You can see a small part of the inside of the sink, and a part of the top surface of the small dividing wall on the right. The vanishing point is a little to the left of the sink on the horizon line. Keep this simple rule in mind: Everything that is nearest to you is large, and as objects move away from you, they become smaller.

This is a very dramatic example of one-point perspective. Can you work out where the vanishing point is? Review the photo before you read the answer in the next paragraph.

The eye level of the photographer is a little above the sign on the lamppost in the left foreground of the photo. If the photographer moved to the right, say 15 feet, her eye level/horizon line would remain the same, but the vanishing point would move along the eye level/horizon line, as her position would have changed. The angles of the parallel lines of the building's architectural ornamentation would be less steep, and less dramatically inclined.

The diagrams in this section use cubes to help further explain one-point perspective. The front of the cube is directly facing you, and so you are only dealing with one vanishing point. All of the horizontal sides of the cube are parallel, and the cube is seen from three different eye levels.

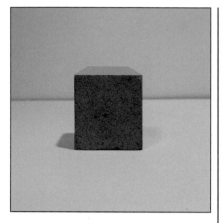

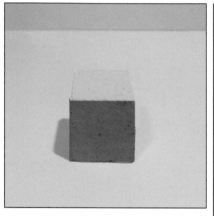

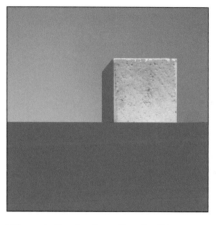

The eye level of the viewer is above the cube. Although the top of the cube is visible, notice that you can only see a small portion of it. This means that the eye level is not that far away from the top of the cube. Both sides of the cube, being below eye level, must therefore come up to a vanishing point at eye level.

To better illustrate this point, take a ruler, lay it along the two top sides of the cube, and join those lines together. You now have your vanishing point and the eye level, or horizon line. See how you can create a sense of depth by making parallel lines converge? The vertical lines (front and rear) on the front sides of the cube always remain vertical. This situation is similar to the photograph of the kitchen island; the island is simply a long cube.

Here, the top of the cube is now even more visible than in the previous example. The eye level must therefore be higher. The parallel sides of the top of the cube are again converging to a vanishing point, but they are doing so less abruptly, because there is a greater distance between the eye level, or horizon line, and the top of the cube. As shown in the photo on page 76, the rugs are similar in perspective to the top of this cube.

Where is the horizon line in this example? Is it above or below the cube? It is actually in the middle of the cube. You can see that the top side of the cube is angling down. However, you cannot see the bottom of the cube, as it is obscured by the table. This can occur in everyday life (see the photo of the building on page 77). If this does happen, you can make a well-informed guess about the angle of the line that is obscured, because you now understand the laws of perspective. This knowledge relieves you from unnecessary frustration when drawing. Understand these simple points, and you can spend more time concentrating on the quality of your drawing instead of trying to determine the correct perspective.

Invent Your 3D World

These diagrams show a simple technique to help you determine the proportions of your object as it recedes into space. You can apply this technique to either a vertical or horizontal plane, as shown.

The first diagram uses the horizontal plane. To draw this diagram, first draw a triangle, and then draw some converging lines within the triangle. These lines correspond to the sides of an object that you may be drawing (such as a tabletop or the top of the kitchen island shown previously), which are receding to the vanishing point. Draw a horizontal line across two lines in the bottom on the left. Now you have a top surface of an object. The red line represents the width of that top surface of the object, from corner to corner. If you repeat this diagonal with the same angle, so that it is parallel to the first and all subsequent diagonals all the way to the vanishing point, you can see how the top surface of the object becomes smaller and smaller in width and length.

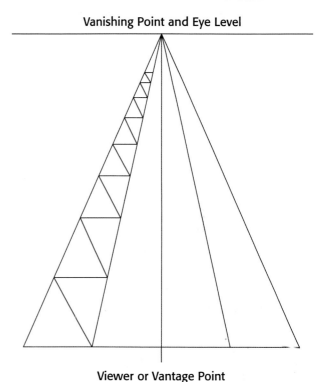

Vanishing Point and Eye Level

Viewer or Vantage Point

In this diagram, imagine that the square nearest to you is the back of a chair in perspective. Notice that if you move that chair farther away from the viewer and closer to the vanishing point, along the trajectory that is mapped out, it becomes smaller. Its proportions are correctly portrayed as the red diagonal lines. Just as in the previous example, all of the diagonal lines are parallel to each other. In this example, the diagonal lines form the correct width of the chair back. You can drop a vertical line where the diagonal meets the top side of the chair. (The top side is parallel to the bottom side of the chair.)

An example where this technique is useful is when you are drawing windows on a wall of a building that is receding into the distance.

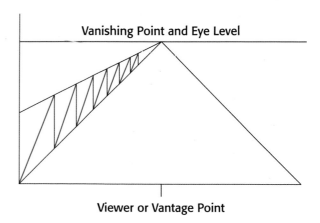

Vanishing Point and Eye Level

Viewer or Vantage Point

Once you understand the terms *vanishing point* and *horizon line*, you can move an object around within a space, even if it doesn't happen in real life.

Here is a diagram of two cubes in a three-dimensional space. These cubes, which obey the laws of one-point perspective, are the same size. As you can see, if you place an object on a surface (floor or table) and draw lines to its vanishing point, you are able to place it anywhere between the foreground and background and still maintain its correct proportions.

This is a very useful technique for constructing a room with furniture that does not exist in reality. If you apply the laws of one-point perspective, you can convincingly achieve the illusion of reality. Practice this exercise by drawing a cube, placing it in a grid, and moving it around your space.

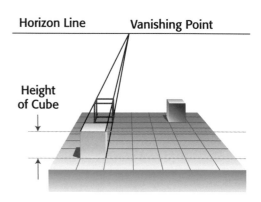

CREATE A CUBE ON A PERSPECTIVE GRID

Once you have determined the width and depth of the cube in perspective, as seen in the diagram above, it's easy to transform this into a three-dimensional cube. The first thing to determine is the height of the cube that you would like to draw. This is achieved by drawing two vertical lines starting on the two front corners of your cube to the determined height. In this case, it's an arbitrary height. The next step is to connect the two tops of the vertical lines (A and B) with a horizontal line. Now simply draw the two top corners back to the vanishing point. Next, repeat the same procedure on the two rear corners of the footprint, bringing them up to the lines that you drew to the vanishing point. Now connect these two points (C and D) with a horizontal line, and you will see that you have now drawn a cube in perspective.

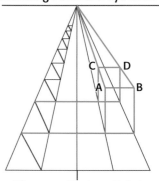

Applying the lessons from the previous two pages, you can construct a cube on your grid at any point within the space of your grid.

In this image, the cars are all parked along the side of the street. Just like the cube example, they recede toward the vanishing point at the same height, because most of them are the same height, more or less. You could draw in another car near the corner, and you would know its exact height and the size of the wheels, if the cars were a similar size.

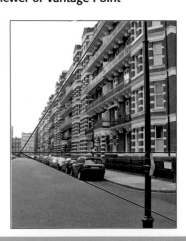

An ellipse is simply a circle in perspective. The cube examples show how the top surface becomes more visible as the eye level or horizon line becomes higher. The same effect happens with the tops of rounded objects.

The horizon line in this example is in line with the top of the object. You draw this simply as a straight line.

In this drawing, you can see more of the tops of the objects. You cannot see the ellipse of the back of the jug because it is leaning slightly away from you.

Aidan with Vases, by Dean Fisher

Look at the array of ellipses in this drawing. Notice how round and smooth the edges are. A common mistake is to make the edges pointed. These edges become rounder as the eye level moves up.

*by Roger Van Damme,
courtesy of the artist*

Try creating a tonal drawing of a similar object from the same eye level as shown here. You may have to practice the shape a number of times, as it can be difficult to draw curves. Pay attention to the shapes of the shadows within the object, and draw the shadows first. In this photo of the same still life setup as the first example, notice how much rounder the ellipses become in the lip of the small bottle and the bowl when the eye level becomes higher.

In this section, you begin a complete drawing using everything that you have learned so far about perspective. You must first set up a still life of your own. Use objects that are square or rectangular in shape, as well as objects with a round top if you want to practice drawing ellipses. Then use a spotlight to light your objects, as shown in the first image. You need to tone a sheet of paper (see "Tone Your Paper" in Chapter 4), a selection of graphite pencils (using H to 6B or softer), and an eraser.

The Horizon Line

The objects on this table are below the horizon line. The horizon line (eye level of the viewer) is the level where all of the sides or lines of the objects that are perpendicular to the viewer converge. Judge accurately, with your eye, the level of your horizon line and place a mark on the wall behind the still life. It is good to place a mark somewhere, so that you do not become confused and forget where it is. You can also mark your eye level on a stick and place the stick next to your setup, so that it is always clearly visible. This is useful when working outdoors in a landscape where the horizon line is obscured. You can place the stick vertically against a structure, up against a tree, or allow for an extra 6 inches at the bottom and stick it into the ground.

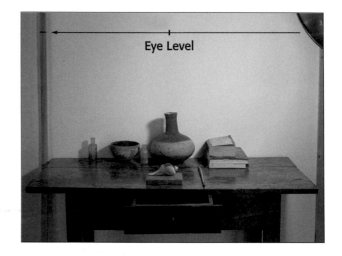

Eye Level

Create your vanishing point by holding up a ruler along the side of any object that is perpendicular to you. If you continue the line of trajectory, it meets the horizon line. If you do this to the other side of the same object, then you will find that this line meets the other line of the object on the horizon line. You have now established your vanishing point.

You can attach a board behind your drawing, as shown here, to indicate the eye level. The eye level is measured here using a scale that is the size of the central pot. The eye level is about two pots high from the surface of the table. Map out your drawing with light lines. Remember to measure (refer to page 44) and draw in your converging lines if you need to, but keep them light!

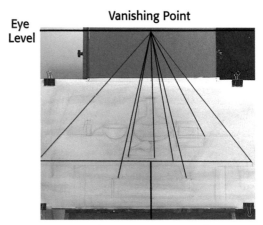

Eye Level

Vanishing Point

Viewer or Vantage Point

Establish more of your drawing by adding other objects to practice ellipses. Add some differently shaped objects that have curves. Add objects of different sizes to add interest to your arrangement. For this image, the artist has added some of the objects that he loves to draw and paint: a small bowl, a small glass bottle, and his favorite large pot. To help you to find the curvature of round objects, see "Find the Angles" in Chapter 4.

CONTINUED ON NEXT PAGE

In the initial stages of learning perspective, it may be useful to draw out the subject with lines fairly extensively, before you begin to shade or erase. In this manner, you can concentrate on the tonal aspects of the drawing without having to worry about problems of perspective. Before the artist began to shade, he "keyed" his drawing by indicating the lightest light and the darkest dark. See "Key Your Drawing" in Chapter 5 for more information.

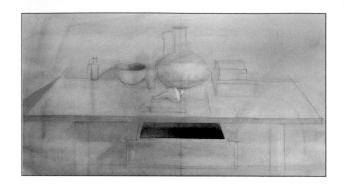

After the artist established keying and perspective, he could begin to give the subject form and space by rendering it in light and shadow—that is, he could develop the tonal relationships of his subject. The artist kept all of the tones very soft here, because he wanted to be able to judge the whole drawing before he defined his shapes.

Note: *Remember to develop the entire drawing together, working from large shapes to small shapes. Don't forget to squint (see page 58); it helps you to judge your tonal relationships without the influence of insignificant (at this stage) details.*

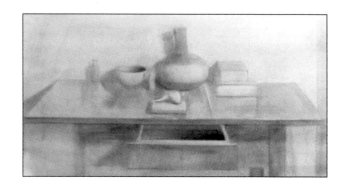

TIP

Build Your Tones Gradually
Try not to get too dark too fast, especially when working with graphite. Otherwise, if you want to lighten an area, you may find it difficult to erase.

With the removal of several large shapes of light and the addition of the darker areas, the drawing begins to look more three-dimensional. The artist has sharpened up the shapes of tone by giving everything more definition. With careful observation of the tones that you see in front of you and careful decisions about what tones you place where in your drawing, you can also capture the quality of your light and create depth in your drawing.

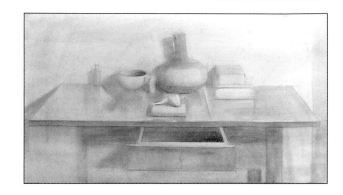

The tone of the paper can serve as the half tones in your scale of value (see "The Half Tones" on page 62). Continue to develop the areas that are darker than the tone on your toned paper. The objects will take on a greater sense of form and weight as the darker tones are added to your drawing. The darkest and lightest tones generally occur in those areas that are closest to you, thereby forming the greatest contrast. These highly contrasted areas create the illusion of objects coming forward, and those areas with the least contrast tend to recede.

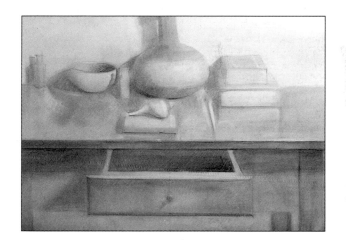

CONTINUED ON NEXT PAGE

To develop the multitude of tonal relationships in your subject, use the peephole method (discussed in Chapter 5) of comparing areas of tone. The more carefully the tones are observed and rendered, the more realistic it becomes. Look for the half tone or transitional tones between the lights and shadows, as these areas help to add volume to your forms.

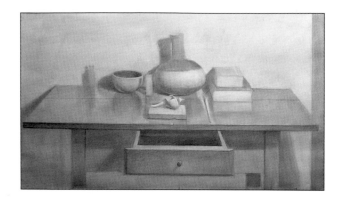

Now that you have rendered the large forms in relation to each other and have constructed a feeling of space and light, you can add a further dimension of reality to your drawing by rendering the individual textures, topography, and nuances of each object.

This is the time when careful scrutiny helps to reveal the individual characteristics of each object. Do not over-render these "secondary" details, or let them interfere with the large areas that you have established; keep them subordinate or else you will lose your foundation.

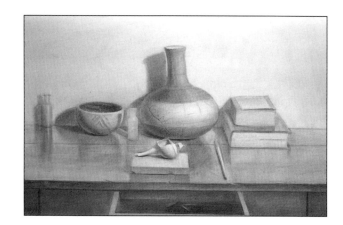

TIP

Remember to continually stand back at least 6–10 feet from your drawing to see if it is working well.

This is the finished drawing. The artist has carefully portrayed the objects with different tones. This portrayal of the light has enabled the artist to create depth, volume, space, and a tactile quality in the drawing. By using one-point perspective, he has rendered all of the objects in a believable space. Light has been revealed through tone, which gives a sense of solidity to the objects. You can see that texture has been created by acutely observing the transition of light and shadow on the surfaces of the objects.

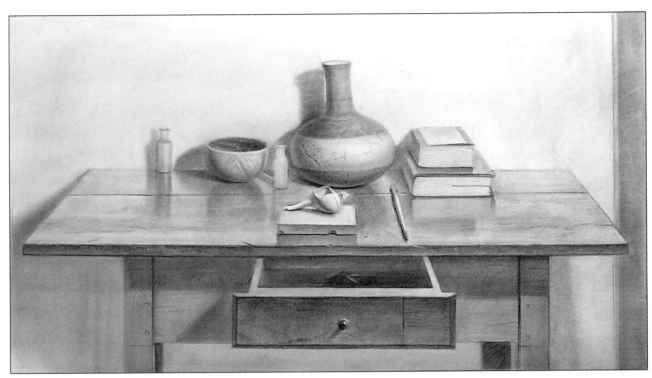

Still Life #5, *by Dean Fisher*

In this pen, ink, and wash drawing, Guardi has skillfully rendered a vast Italian plaza. With great knowledge of rendering light, form, and space, and an understanding of perspective, the artist has used very abbreviated forms to capture the essentials of his subject.

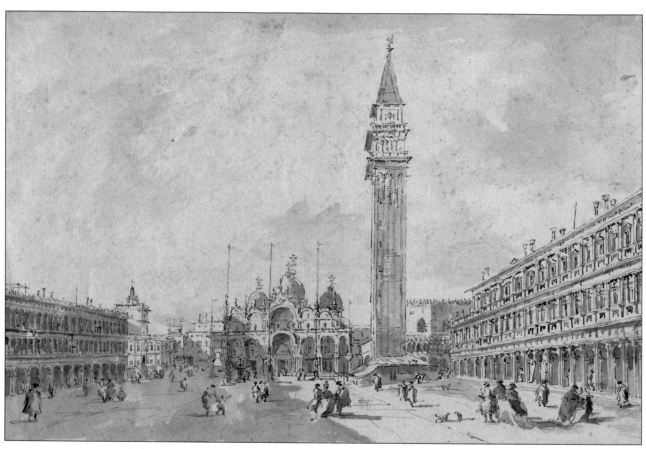

Piazza San Marco, Venice, *by Francesco Guardi,* © *Cleveland Museum of Art*

In this very precise one-point perspective drawing of an interior, Antonio López Garcia has masterfully controlled the value of his tones to depict and juxtapose a lit room next to an unlit room in an extremely realistic manner. The value of the light slanting across the unlit room is observed with great precision. Every element is carefully considered within the composition as a whole. This sense of unity and completion opens the drawing's meaning up to interpretations, which reach beyond the "realism" of the scene.

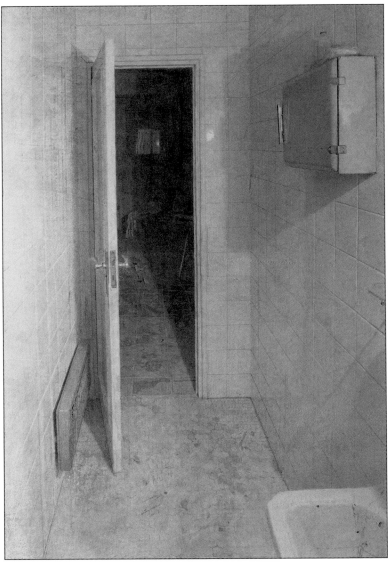

Interior de Water, *by Antonio López Garcia,* © *VEGAP*

CONTINUED ON NEXT PAGE

Although this image is a painting, it is included here because it displays the artist's knowledge of perspective. Once you have mastered the rules of perspective, you can create a believable space such as this. One-point perspective is used to dramatic effect to suggest the wide, lonely, seemingly never-ending road of a Texas town. The painting has a precision of drawing objects in perspective which adds to its very believable sense of realism. Through its accuracy, you can get a very clear sense of the vantage point, eye level, and the horizon line of the artist as he viewed his subject.

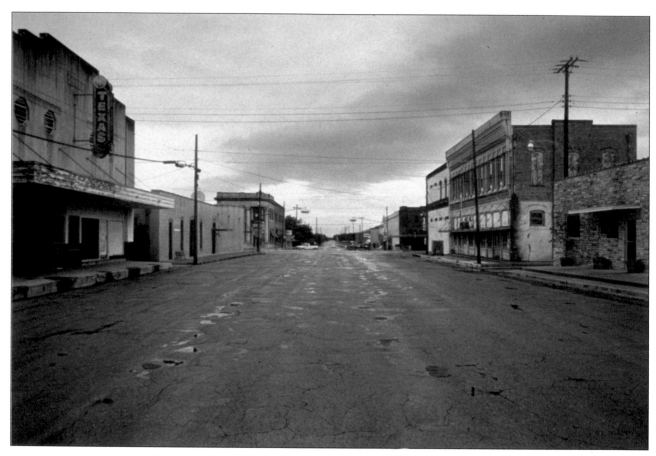

Passing Storm/McGregor Texas, *by Rod Penner, courtesy of the artist and OK Harris Works of Art*

In this precise, formalized street scene, the artist has an acute sense of observation. The lamp posts and sign posts are emphasized with a darker tone. This accentuates the curve of the sidewalk, which leads our eye, first around this curve, and then toward the vanishing point. In contrast to Penner's painting (on the previous page), Gaetjen has suggested a more closed and narrow space by using this compositional device.

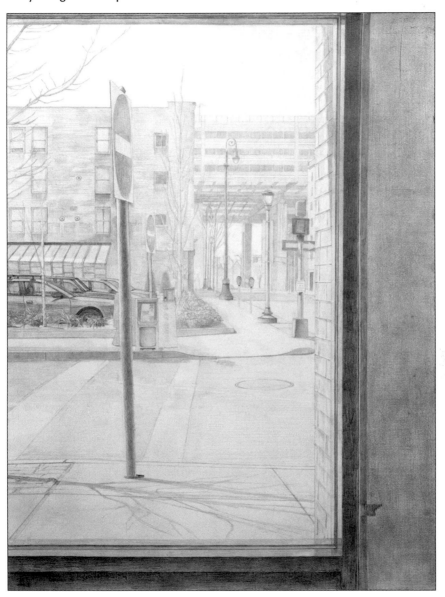

Crown and Orange Streets II, *by Josh Gaetjen, courtesy of the artist*

CONTINUED ON NEXT PAGE

In this arresting drawing, Eder has used the full tonal range of the medium, from white to black, to create an image with a strong visual impact. The chair seats are drawn in one-point perspective, but the compositional element is directed by the pattern of shapes of light and shadow. The mysterious red lines seem to be incongruous at first glance but in fact give a visual strength and added structure to the drawing.

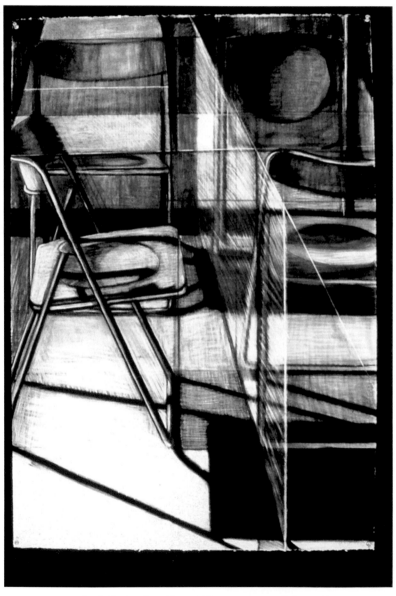

Musical Chairs, *by Eileen Eder, courtesy of the artist*

In this drawing, the complexity of New York City is surveyed from a high vantage point. New York was built on a grid; consequently, this is mainly a one-point perspective drawing. However, not all of the streets were incorporated into the grid, and so there are also some two-point perspective examples here (see Chapter 7). Distance is suggested in this drawing, not only through perspective and proportion, but through drawing the prevailing atmosphere. The concrete, solid buildings turn to shimmering cutouts in a late-afternoon light.

Looking Downtown II, *by J. S. Robinson*

Add More Dimension to Your World: Two-Point Perspective

While one-point perspective was most often used by artists throughout history, it is more common for artists to view reality in *two-point perspective.* Two-point perspective takes into account an object's visible side angles versus the face-on appearance of an object in one-point perspective.

For this reason, it is important to understand the rules of two-point perspective and to see, when applied well, what a useful vantage point it is for creating very interesting art.

Introduction to Two-Point Perspective

The major difference between one-point and two-point perspective is that one-point perspective has one vanishing point, and two-point perspective has two vanishing points in different locations on the horizon line.

Three-dimensional rectangular forms, such as buildings, cars, and tables, have vantage points where the two sides of the object are seen at the same time, as in the example of the barn pictured here.

When objects (whether in a landscape, city, or townscape) or an interior are placed at different angles to each other, you will find that their parallel sides converge toward different vanishing points.

Even though these examples have multiple vanishing points that fall on the same horizon line, this is still referred to as two-point perspective.

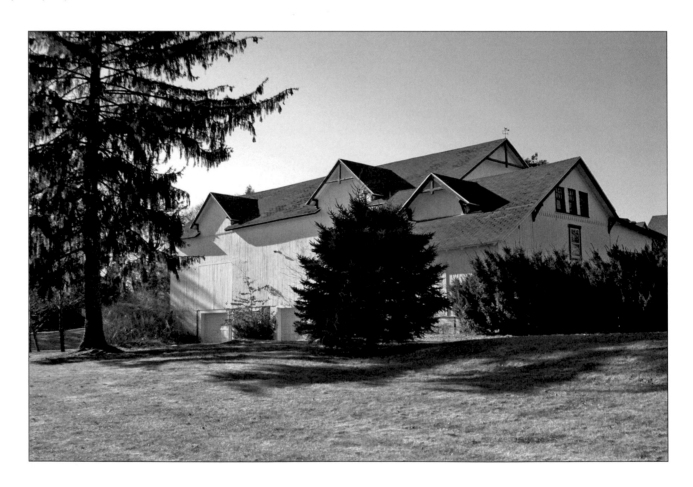

Now that you are familiar with the principles of one-point perspective, understanding those of two-point perspective shouldn't prove too difficult for you. As you can see in the diagram below, all of the familiar terms are being used: vantage point, eye level, horizon line, and vanishing point.

As shown in the diagram of the barn, the vanishing points often fall well outside the field of vision of the viewer or the camera lens.

When trying to determine where the vanishing points are, it is helpful to tack pieces of paper on either side of your drawing paper, or to place your drawing paper on a large board when constructing objects in perspective. You can use this technique in the drawing demonstration on the following pages.

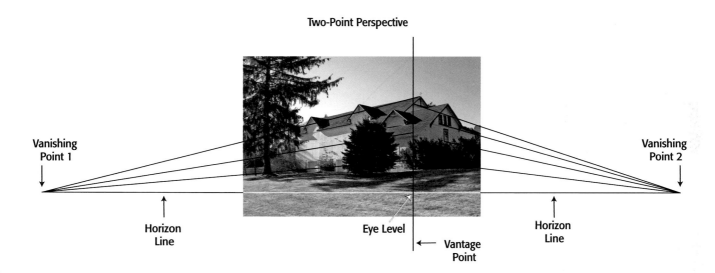

Two-Point Perspective

Vanishing Point 1

Vanishing Point 2

Horizon Line

Eye Level

Vantage Point

Horizon Line

This exercise will help you to gain a more complete understanding of two-point perspective. You will study three photos with different eye levels, where the cubes are placed at different angles to each other. After you complete this exercise, you will be on your way to drawing any object in front of you in accurate, two-point perspective.

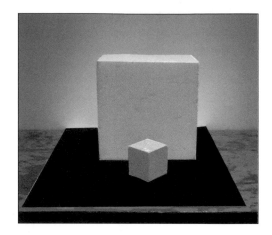

Tape a 16" x 20" sheet of tracing paper over the photos on this page and trace each configuration of cubes. Remove the tracing paper from the photo and place it on a table or flat surface. With a ruler or straight-edge, construct a perspective diagram for each of the photos, similar to the one on the previous page.

As shown in the two-point perspective demonstration on pages 104–113, an artist has constructed a similar diagram to precisely draw a barn in perspective.

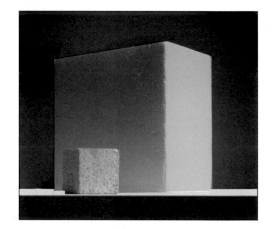

The diagrams that you are creating in this exercise are similar to the diagrams that the masters of the Renaissance used to construct their drawings and paintings.

As your eye becomes more trained and your drawing skills more precise, you will be able to combine the methods discussed here with direct observation to accurately draw objects in perspective.

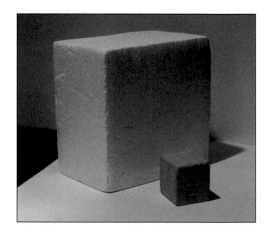

TIP

Three-Point Perspective

There are some instances where three-point perspective can occur, such as when you are drawing cityscapes and you are on the street looking up at a tall building, or when you are inside a tall building looking down at the street. In the first example, both sides of the buildings are visible, as in two-point perspective; the third vanishing point occurs as the vertical lines of the building converge up in the sky. When looking down from a building, the vanishing point occurs below the ground level.

In a more common example, the same three-point perspective occurs when you are standing above a table and are looking down on the tabletop (pictured in the photo at the right). You will notice that when the legs are visible, they too converge toward a vanishing point somewhere below the floor. Also notice that the bottles and the vase are converging toward the same vanishing point.

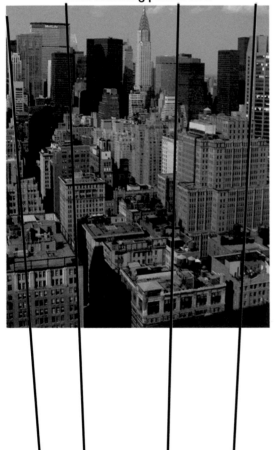

Vertical lines of building coverage toward third vanishing point below

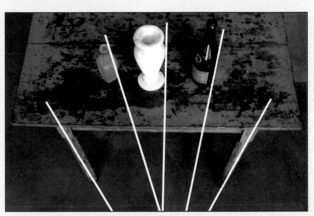

Here are several examples of two-point perspective, any of which could be an excellent subject to base a work of art on. There are similar two-point perspective subjects all around you, with which you can apply the principles that you are learning here to create some beautiful drawings.

This interior photo is entirely in one-point perspective, with the exception of the open door, which is neither parallel nor perpendicular to the viewer, but on an angle. This gives it its own vanishing point.

This aerial view in New York City is also mostly in one-point perspective, with the exception of the one building that is on an angle and whose sides converge toward their own vanishing points on the same horizon line.

This photo of a coffee table is an example of two-point perspective, with the front and back of the table converging toward one vanishing point, and the two sides converging toward two different vanishing points. However, if you look carefully, you will notice that the books are slightly skewed, and if you were to draw them accurately, their sides would converge toward a separate vanishing point.

The cappuccino maker has its own two vanishing points, and the salt-and-pepper shakers have their own vanishing points (each of them is at a different angle to the cappuccino maker). However, as all of the elements in this photo are viewed from the same eye level, all of the vanishing points fall on the same horizon line.

Drawing Demonstration: A Barn in Two-Point Perspective

In this exercise, we are going to draw a building in two-point perspective. There is a barn located near us, which we will use for this exercise. Find a building in your own vicinity, so you can follow the same steps to create your own drawing.

The Barn Under Construction

We will begin this drawing in a careful, methodical fashion, making sure that the initial "construction" lines (or guidelines) that you use to place your building in two-point perspective are precise. You will be happy that you took the time to do the preparatory work, especially when you begin to render your subject in light and shadow, as you will be able to concentrate on the rendering of the drawing, knowing that everything is in its right place. This can potentially save you a lot of time in the long run, as you will not have to redraw portions of your drawing that are incorrect.

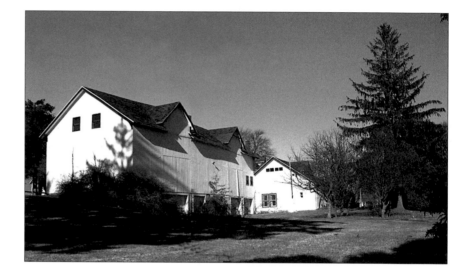

Because the initial drawing of the barn, or building you choose, in two-point perspective is quite technical, it is a good idea to draw the building on a very lightly toned paper so that the guidelines remain visible.

After this stage, we can do a more elaborate line drawing, keeping the lines very light. We will proceed to render the light and shadow by erasing the light areas with the kneaded eraser and by adding graphite (gradually) with the pencil. We will then smooth it out with a paper towel and tortillon. Follow these steps along with us, as you draw your own building.

Begin by establishing the vantage point (where the viewer is standing) and the eye level, which determines the horizon line and vanishing points. Then, very lightly draw the large forms of your building, as we have done with our barn (see photo on the next page).

TIP

Employing the measuring methods used in the section "Measure Your Object" in Chapter 4 can help you to achieve the correct proportions between the trees and the barn, as well as each individual element of the subject.

If the vanishing points of your building, like our barn, fall outside of the paper on each side, you should work with a drawing board (or on a drawing table) that is wide enough so that you can plot the position of the vanishing points as a guide for the construction of your drawing. Remember, when in perspective, all horizontal lines of the building converge at the vanishing points.

In this exercise, we will draw a *high-keyed* tonal drawing of our barn and its surroundings. We want you to do the same with your building. High-keyed means that you will render the majority of the drawing within the light end of the tonal scale, which is about the lightest 50 percent of the grayscale, from white to 50-percent gray. There will only be a few select dark tones or accents in the drawing, which will impart an atmospheric and airy quality to the image.

You can continue to lightly add more subject information, always checking the horizontal lines on the sides of your building to make sure that they converge to the vanishing points.

The large shapes of the trees surrounding our barn, and in the background of our drawing, are indicated in this initial stage of the drawing, as they are useful in establishing the proportions of the barn itself. Look around you and see if there are any elements in your landscape that you can use to help establish the scale of your building.

As you gain more experience observing the world around you, you will start to notice when something is "off," especially when it comes to architectural forms. Even the smallest shape that should converge at a particular angle will stand out when it's incorrect.

There really is a lot to be said for a work of art that includes architectural forms that are drawn accurately. It can make the difference between houses and buildings looking as if they're made out of soft, weightless cardboard or something more solid and substantial. Aside from creating firmness and a sense of weight in your structures, it also firmly plants the buildings, homes, cars, and other elements on the ground and effectively defines the ground plane. Taking the time to understand the laws of perspective and to employ them in your work will make your drawings more convincing and impart a higher level of realism.

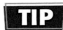 **TIP**

Even though the topography in this subject is somewhat hilly, it is more or less a flat plane that is also affected by the laws of perspective.

Notice that the long shadow that is cast in the left foreground also converges toward the vanishing point on the right side.

CONTINUED ON NEXT PAGE

Now lightly draw in your building and any other elements you want in your composition, as we have done here. Even without any shading, because of the accuracy of the lines, the building and tree already have a sense of form.

The shape of the tree is carefully observed, and it's "gesture" captured, which also lends it a natural feeling.

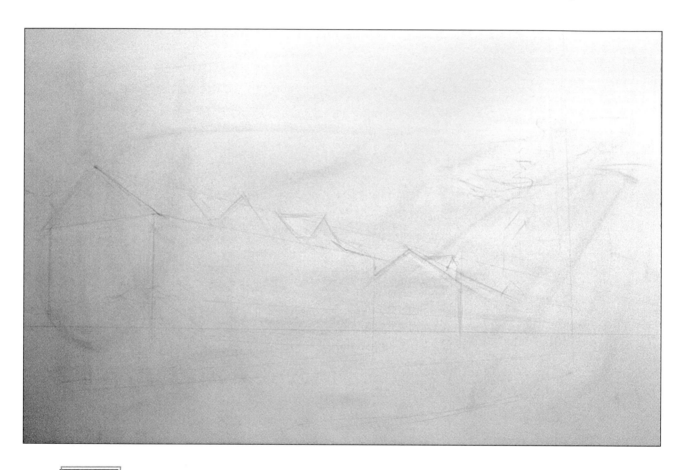

TIP

If you look carefully at the overall shape of each tree, you will notice that every tree has its own "personality." Each has a unique shape, character, and "gesture." Be careful not to fit your trees into your picture by shrinking them down or cramping them, because they will lose their grace and elegance. Observe how branches in most cases taper very gradually. Tapering the branches too abruptly gives them an artificial look.

More information on the drawing and three-dimensional modeling of trees is discussed on pages 272–273.

In this stage of our drawing, more of the tree and barn are developed in line after checking thoroughly that all of the angles of the barn converge correctly toward their prospective vanishing points. As the tree is developed, each branch is carefully observed for its particular shape and how it fits into the overall rhythm and gesture of the tree.

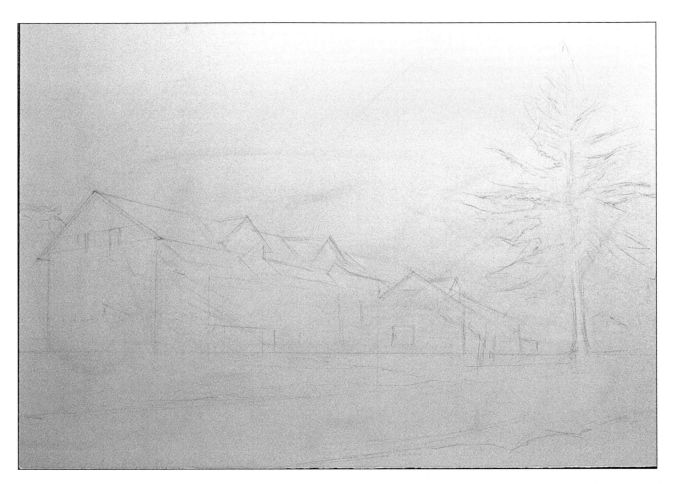

CONTINUED ON NEXT PAGE

LIGHT AND SHADOW

Now that the drawing of the subject is more advanced, you can focus attention on developing the drawing tonally. As mentioned earlier in this chapter, this will be a "high-keyed" drawing by focusing on the lightest half of the tonal range, from white to about 50-percent gray. This means that you will have to gradually and selectively develop the darker areas of your subject.

By pushing most of the tones toward the light end of the tonal spectrum, notice how you can create the illusion of a dark tree by only shading the tree to a mid-tone (gray). It appears to be dark because it's surrounded by so many light tones.

This is another example of how each area of the picture influences the way the rest of the picture is seen.

Building on what you have learned in Chapter 5, you can establish patterns of light and shadow throughout your entire drawing. In this image, notice how quickly a sense of atmosphere and space are created using just basic light and shadow shapes.

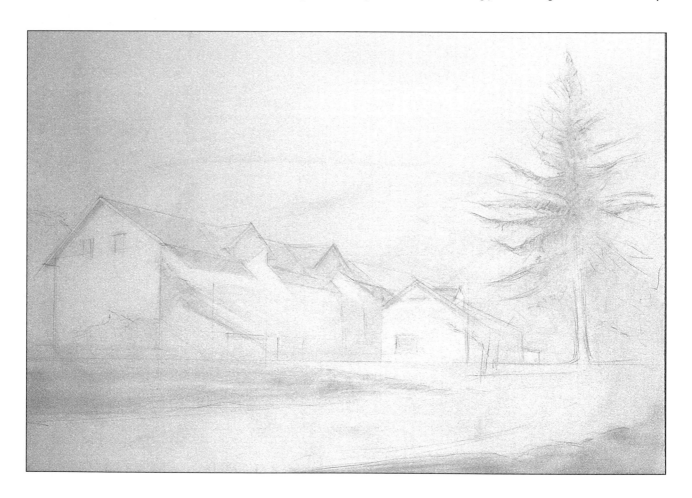

After more tonal development, we have placed a few darker accents in our composition. These dark accents help to stress the lightness and airiness of the drawing, by making the light areas appear even lighter.

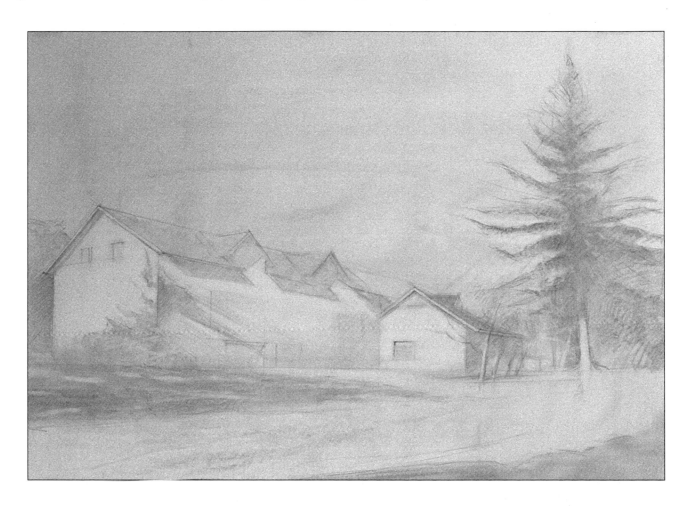

TIP

Recognize Tonal Differences

Because this drawing is rendered in a small range of tones, the changes between tones are subtle. Achieving the subtle differences between tones is easier if you smooth out the graphite with a tissue or a paper towel.

CONTINUED ON NEXT PAGE

In this stage, more detail is included. Always check to make sure that these elements conform to the perspective that you have already established. It is highly recommended that you use a long straight-edge to draw all of the horizontal lines to their respective vanishing points to ensure accuracy.

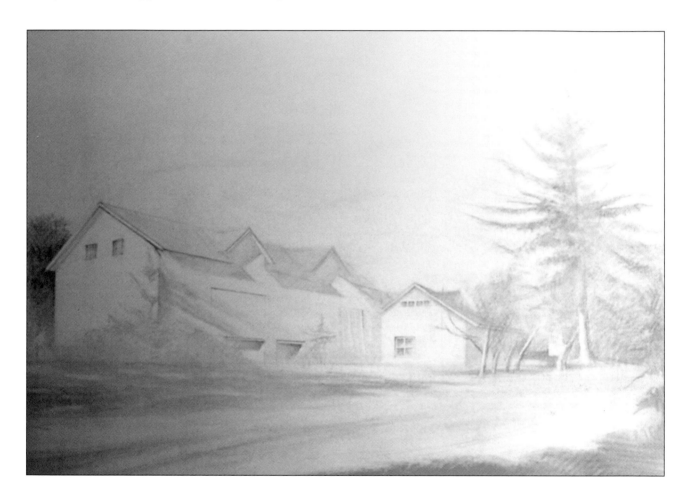

In these images, you get a clearer idea of how the illusion of reality is developing. It isn't developed through the use of countless details, but through an approximation of the various tonal relationships between all of the elements in the drawing. The realism is also brought about through accuracy in the drawing.

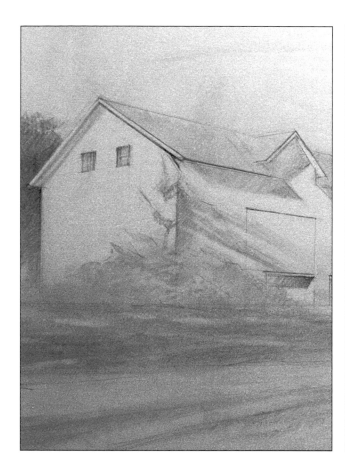
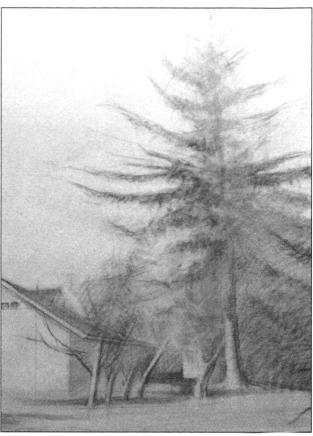

CONTINUED ON NEXT PAGE

Now that all of the large forms are in their correct perspective and look solid and lit, it's time to give the drawing a sense of completion. Adding the subtle nuances in tone and incidental details in each area imparts a sense of texture. Notice how breaking up the large area of tone in our drawing that represents the grass, by drawing some individual clumps of grass in a few areas, begins to create a sense of focus; it also helps the illusion of dimension by bringing the foreground closer to the viewer.

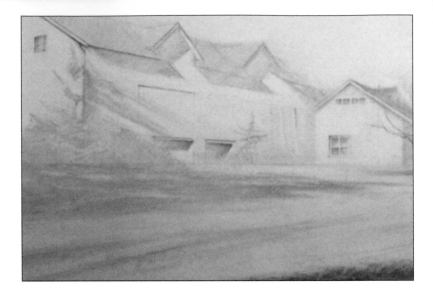

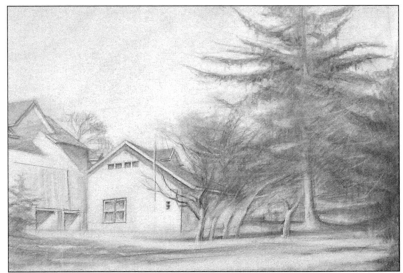

Here is the finished drawing. The addition of some detail and texture gives a sense of completion to the drawing. Special care is taken to not overmodel the areas of detail. If the light areas had been punctuated with darker detail marks that were too dark, then the feeling of light flooding the area would be lost. A good example of this is in the vertical slats of wood siding on the barn. They only have to be subtly indicated to explain the nature of the structure to the viewer.

The best way to test whether the details that you're adding to your drawing are either working or hindering the work is to periodically step back at least 10 feet from your drawing. If it jumps out at you too much, it's either too darkly or crisply drawn, or the accuracy of the perspective is incorrect.

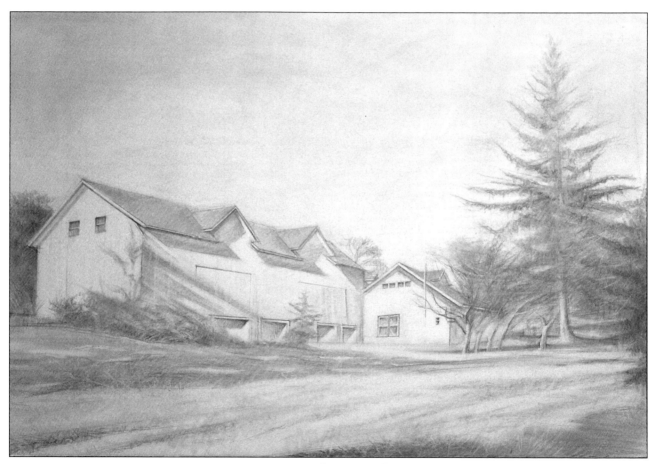

Stowe Barn, *by Dean Fisher*

In this gallery of drawings, you will find several of the many ways that two-point perspective can be used to create very interesting drawings. As an exercise to sharpen your understanding of the principles of two-point perspective, place a large sheet of tracing paper over each of the examples and construct a perspective diagram, as discussed on page 100.

In this diffuse, mysterious urban landscape, the artist has added to the sense of ambiguity through the use of the two diverging roads going off to each side of the paper into an unknown space. Adding to this feeling is the driveway that enters the building on the left, which also looks empty and undefined.

Afternoon on Crown, *by Constance LaPalombara, courtesy of the artist*

In this extremely precise, two-point perspective drawing of an aerial view of a city, the artist has created a crisp and clear rendering through the use of very defined lines and shapes. The extensive use of the white of the paper adds to this feeling of clarity.

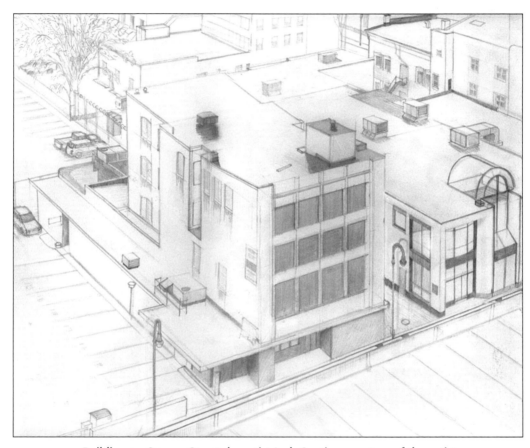

Building on Orange Street, *by artist Josh Gaetjen, courtesy of the artist*

CONTINUED ON NEXT PAGE

This is a beautiful pen and sepia study for a painting. The use of two-point perspective in this work is subtly and effectively used. Beginning with the rug on the floor, which is placed at an angle at the bottom of the drawing to put it in two-point perspective, an arrow has been created. The arrow is a device to lead the viewer into the work. The box on the table is an important element for this theme because it is also placed in two-point perspective and is seen from above to accentuate its volume with the figure reaching into its mysterious depths.

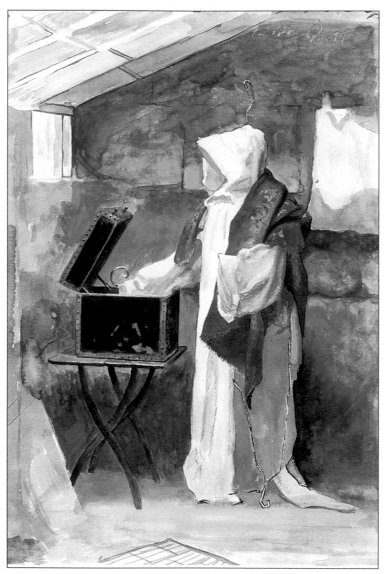

Pandora, *by Justin Wiest, courtesy of the artist*

In this drawing, which is a study for a portrait of a young boy, the architectural forms are in two-point perspective. These forms are being used as a device to help carve out a three-dimensional space in the picture, which enhances the form of the figure in the composition.

Portrait Study, *by Jack Montmeat, courtesy of the artist*

chapter **8**

Discover the Potential of Line

In this chapter, you will learn various approaches to line drawing. When thinking about drawing with line, you may say to yourself, "but I can't even draw a straight line." This shouldn't be an obstacle to working from nature because straight lines very rarely exist in nature, if at all.

Introduction to Line Drawing

Based on the archaeological evidence, it appears that approximately 25,000 to 30,000 years ago, line drawing was one of the visual ways our earliest ancestors employed to record aspects of the world that they inhabited. To anyone who has seen images of cave drawings, in books or in the actual caves in southern France and Spain, it is clear that these individuals were skilled. These line drawings are pure examples of artistic expression.

Practice to Develop Your Style

Humans perceive reality in terms of relationships between shapes of tone. The junction where one shape of tone meets another is evident as the edge of an object meeting another edge. Early humans perceived this and in their desire to give representation to this phenomenon of the edge of one object meeting another edge, visually, they drew a line. With a leap of creativity, early humans invented a language for a visual shorthand, which to this day is still practiced by artists in a multitude of ways. It remains one of the most expressive, varied, and disciplined ways of drawing.

There are so many ways that artists have used line drawing that an entire book could be devoted to displaying examples of them, yet the book would only scratch the surface of the subject. In this chapter, you will find a number of examples that are quite different from each other and that are intended to start you working with and thinking about line drawing.

The more you practice to develop your skills and experiment with different methods of line drawing as an artist, the more you will be able to see your own personal drawing "signature" begin to emerge in your drawing. This is a natural process and shouldn't be forced; otherwise, you run the risk of hindering the learning process and developing a contrived style in your work. If you work diligently, with an open mind and a spirit of exploration of study, you will find that new surprises will materialize in your work as you evolve technically and artistically. This is what it means to work as an artist.

Leonardo da Vinci's great technical skills are evident in this copy of "The Head of Saint Philip". He has achieved the illusion of a human head in profile with sparse shading and one dominant line. The majority of the drawing consists of this single line of varying thickness that describes the profile of the young man. The minimal amount of shading gives volume to the head, but the accuracy and control of line are responsible for this very natural and lifelike portrait.

Copy after Leonardo da Vinci's Head of Saint Philip, *by Dean Fisher*

In this section, you can view examples of line drawings. Each drawing has an explanation that describes just some of the qualities of line that are possible. A close-up on a portion of each image is also provided. The quality of line that is achieved is the result of many factors that came together to create an image that is a unified drawing representing a focus of *artistic intent*. This artistic intent is the blending of what feeling or idea the artist wanted to communicate originally, with the technical means to clearly convey it.

Aside from the personality of the artist and what the artist wanted to say about the subject, there are other factors that helped to determine the outcome of the work. One of them was how much time the artist had to complete the work. For example, an artist has to work much faster when drawing a horse, which is in continuous motion, compared to a tree, which is planted firmly in the ground. The amount of time a drawing takes to complete greatly affects the energy and strength of the line. If you look closely at a drawing, you can get a sense of the speed with which the line was created.

Another factor that determines a drawing's outcome is what materials were used in its creation. Chapter 2 introduced examples of a variety of types of marks, and showed how the texture of the paper and the type of drawing medium used determine the quality of the mark that is made.

Over time, as you experiment with different materials and develop your drawing skills, you will find yourself gravitating toward the drawing media and papers that best suit your personality as an artist.

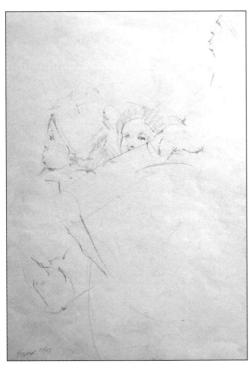

Children on a bus, *by Dean Fisher*

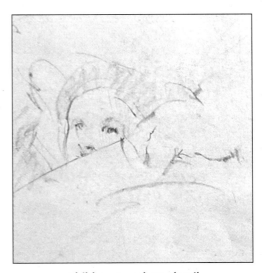

Children on a bus, *detail*

CONTINUED ON NEXT PAGE

This is an example of a continuous line drawn with a black ball-point pen. In this type of drawing exercise, the pen (or pencil) is never lifted off the paper, and the goal is to capture the feeling of the pose rather than the details. A close-up of the drawing on the right shows how even the smaller shapes of the figure are drawn to indicate expression more than accurate representation.

As an exercise, create a continuous line drawing—first a still life and then, as you gain confidence, try to draw a landscape or figure.

Figure Study, *by Dean Fisher*

Figure Study, *detail*

These are rapid pencil drawings of a horse in motion. The artist had to work quickly as the horse changed its position every few seconds; as a result, the line is forceful and fast. The line changes from thin and light to heavier and dark, creating a sense of energy and movement. As you draw moving objects, you may notice similarities appearing in your lines.

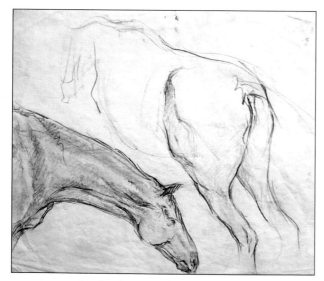

Study of Horses, *by Dean Fisher*

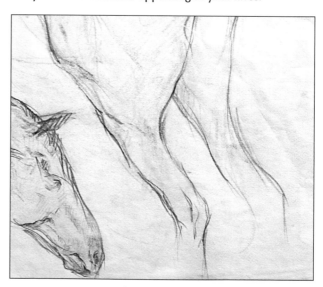

Study of Horses, *detail*

In this example, notice how this heavier "searching" line imparts a completely different feeling from the two previous examples. It appears that, after establishing the gesture of the pose, The artist worked around the figure gradually, in short segments, refining the marks to make them more descriptive of the model. Also notice how the repeated double or triple line conveys the illusion of a figure in motion.

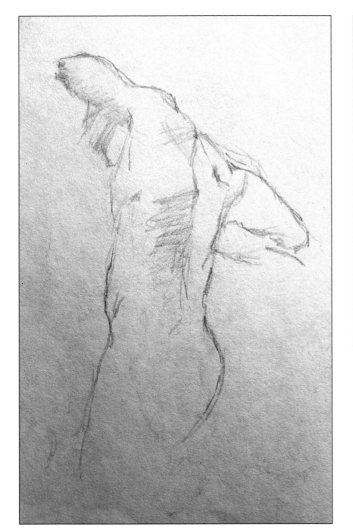 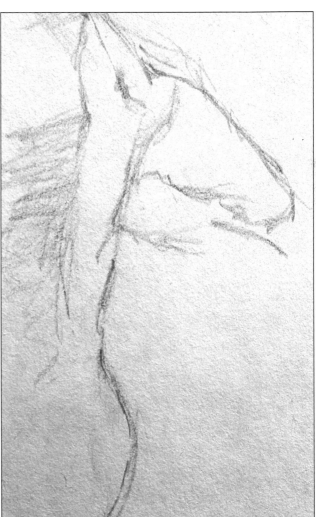

Figure Study, *by J. S. Robinson*

CONTINUED ON NEXT PAGE

In this drawing, there is a combination of long fluid lines that accentuate the slightly elongated proportions of the subject, and shorter hatched lines that often follow the direction of the form to indicate the shadows. There is a range from very thin, crisp lines drawn with the sharpened tip of a pencil, to lines that are broader and softly drawn with the side of the pencil point. This softer line quality can be seen mostly in the hair, and helps to convey its soft texture (see the close-up image on the right).

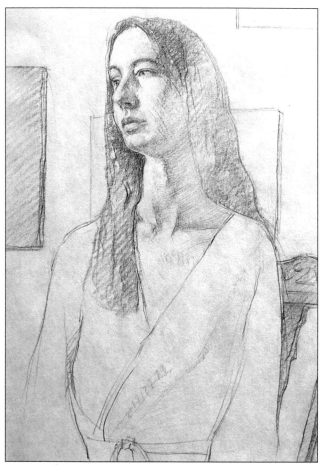

Portrait Study, *by Dean Fisher*

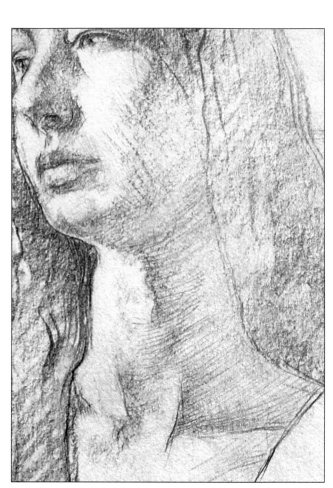

Portrait Study, *detail*

This figure is drawn using sepia conté crayon. The drawing has a beautiful, light fluid line that is punctuated by a number of carefully placed darker accents. These dark accents serve two functions: First, they indicate deeper recesses of the form and in contrast allow other forms to emerge. Second, they help to create a rhythm in the drawing, based on their spacing from each other and the variety of sizes leading the viewer's eye around the drawing in an orchestrated fashion. The orange-brown color of the conté crayon imparts a feeling of warmth and light to the drawing.

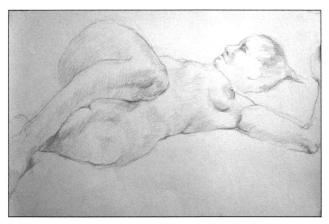

Horizontal, *by J. S. Robinson*

Horizontal, *detail*

In this charcoal drawing, the figure has a visual impact, and its dynamism is created through the use of decisively placed heavy lines and marks. In some instances, the point of the charcoal is used, and in others, the line is drawn with the edge of the point of the charcoal stick. To indicate shadow, the side of the piece of charcoal, or charcoal stick, is used to different degrees of lightness or darkness, depending on how softly or firmly the charcoal stick is pressed against the paper. Of course, all of these confident marks have an effect because they are placed on a sound *armature.* Consequent upon this, the gesture is very believable and natural looking.

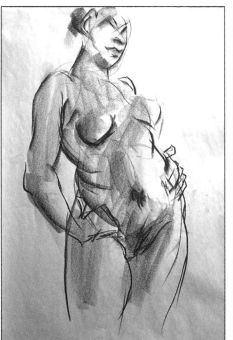

Figure Study, *by Frank Bruckmann, courtesy of the artist*

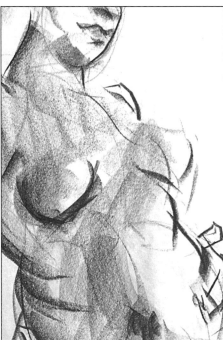

Figure Study, *detail*

Irregular Objects as Still Life

In the previous chapters, the objects used for drawing exercises were not overly complex forms. In this chapter, you will be introduced to irregular shapes, often referred to as *organic* forms. These are objects that possess shapes that don't conform to the geometric forms (spheres, cylinders, and cubes), and that have a more random appearance.

As you can see, a beautiful palm was chosen as the main subject. It has very elegant, graceful lines and shapes, and perfectly lends itself to a line drawing exercise (see pages 132–137). The other objects in the still life setup—the Christmas cactus, seashell, and broken pot—are other examples of organic forms.

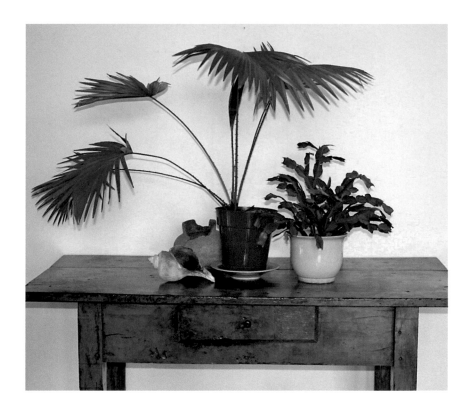

You can consider this still-life arrangement as organic by nature because each object doesn't outwardly conform to a large geometric form. However, when you look closely, there are a number of unifying rhythms to be found in the setup, which then tie all of the objects together.

Once the drawing exercise begins on page 132, you should attempt to create a rhythm in your own drawing, based on what you find in your still life.

As well as a rhythm that links the objects together, it is also possible to impose some geometric forms on the arrangement as a whole. In the diagram on the right, a triangle and some rectangles (few shapes) have been placed over the still life setup to indicate some geometric forms. When attempting to create a unified composition, it is useful to break the subject down into its basic geometric forms. It is also helpful, when establishing the proportion of one object to another, to simplify what you're observing into basic squares, rectangles, triangles, and circles.

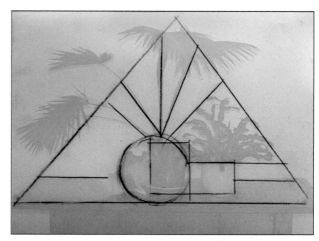

Because of the complexity of accurately drawing the objects in this still life setup (see page 126) and their relationship to each other, this would be a good time to introduce the *grid* as a tool to assist you.

This is a great system for beginners, or for those individuals who struggle with proportions, to achieve a very high level of accuracy in their work. The grid is a great way to initially "map out" the forms of your subject. You can also use the grid throughout the entire drawing process to help you find even the smallest of shapes and their relationship to each other.

While this may seem to be an overly mechanical method of drawing for some, it is a great way to begin training your eye to see shapes. As you become a more trained artist, you most likely won't feel the need to use the grid the entire time, or you can just use it as a way to check for errors in your drawing.

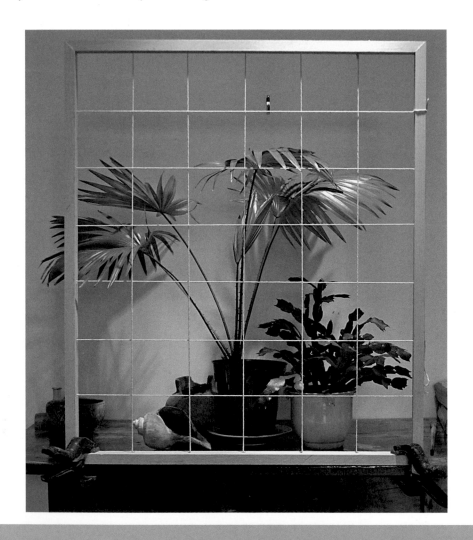

This section provides the instructions for constructing your own grid. You can also purchase a wooden picture frame or artist's canvas stretchers for this purpose if you don't have the tools to build the frame.

1 To make the grid pictured on the previous page, construct a simple 28" x 20" wooden frame from a 1" x 2" piece of wood cut to length. Be sure that the corners are perfectly square when joining these pieces together.

2 Drill ⅛" holes every 4" on all four sides of the frame. You'll need to be accurate in your measurements because otherwise, the lines of the grid will be off.

3 Run string or heavy thread through all of the vertical holes to form the horizontal lines, and then run a separate thread or string through all of the horizontal holes to form the vertical lines. It's essential that the string be pulled taut to accurately create 4" squares.

4 To use the grid, you can clamp it to the table in front of the still life, making sure that the frame is vertical from both the front and the side.

Note: *Before you attempt to clamp the grid to the table, make sure that the tabletop is level; this makes it much easier to place the grid level and vertical in front of your still life.*

TIP

Alternatively, you can draw the 4" grid of squares on a transparent piece of acetate with a black marker and then staple it to the wooden frame. This might be easier to construct, but the drawback is that the glare of light on the acetate might be distracting while observing the still life through it.

You can use this method to draw your still life's actual size. If you would like to draw your picture at less than life size, then smaller squares can suffice as long as you measure them accurately.

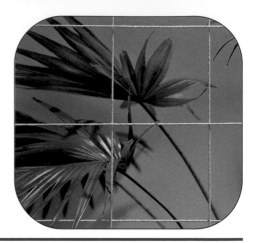

After you place your grid in front of your still life setup, carefully measure and then draw 4" squares on your paper to mimic the squares on your grid. The goal is to have a proportional grid on your paper to match the one in front of your still life.

The photo above shows several squares from the grid, which demonstrates how effectively this tool breaks down the still life into fragments or small frames of the entire setup. By focusing on the placement of the shapes of the palm *frond* (leaf) within each square, the grid enables you to see the subject as a series of abstract shapes. This helps you to render a more accurate and sensitive depiction of the palm frond. In effect, you are actually zooming in on the plant and scrutinizing each area to assist you in drawing what you see, rather than what you think the plant should look like.

It is also very important that once you begin drawing, you should stand in the exact same spot the entire time when measuring your drawing through the grid (just like the other forms of measuring, which are discussed in Chapter 4). Any slight change in where you are standing alters the view of the still life in relation to the grid. To ensure that you stand or sit in the same place each time, you can use masking tape to mark the position of your feet or the chair that you're sitting in.

As you continue to draw the shapes that appear in each square, the entire subject gradually emerges and should be in complete proportion to reality.

While you are looking at the *positive* shapes of the leaf within the squares, you should also look at the *negative* shapes that are formed around the leaf within the shape of each square. It is often easier to "find" the positive shapes of the objects that you are drawing while focusing on the negative shapes.

The yellow color around the leaves indicates what some of these negative shapes look like in the setup, as seen through the grid. This is what the drawing looks like in the initial "mapping-out" of the forms of the palm frond.

Notice that the first shapes are generalizations of the complex frond. After you establish the overall shape, it is much easier to find the shape and position of the small, spiky forms of the frond.

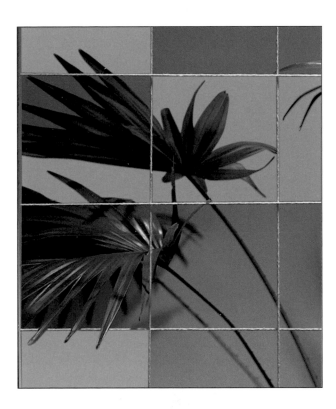

TIP

Make sure that you draw your initial lines very lightly so that you can easily erase any mistakes.

Block In the Setup

With the still life setup of the plants, the seashell, and the pot, and the grid clamped vertically to the table in front of the objects, you can proceed to "block in" the entire drawing.

Capture the Gesture

While you continue to focus on the shapes that fall within each square, look at the entire shape of each object and how they relate to each other. The plants especially have very beautiful, sweeping forms, and at this time, you should try to capture the gesture of each plant. The *gesture* of a tree, plant, or figure is the general overall movement of the main forms; this can usually be represented by a couple of long, flowing lines. Notice that every plant, tree, or figure has a unique gesture, which is a key quality to capture in your work. It is one of the main things that give the subjects you draw a sense of believability and character.

In this stage of the drawing, the artist mapped out all of the objects in the setup and their relation to each other. Be sure to check each square on the grid to ensure your drawing's accuracy.

At this stage, while still using the grid, you can begin to refine the shapes of the objects, attempting to make each line descriptive of each object. In this example, some lines were erased and redrawn, as they became too heavy in the earlier stages.

The artist also varied the thicknesses of the lines, using a heavier, darker line to give the illusion of objects emerging in the drawing, and a lighter, more delicate line for those areas that needed to spatially recede. The artist was also beginning to develop the design of the drawing. While looking at the entire still life setup, the artist searched for a rhythm of shapes and an internal structure between the objects. There are lines that flow from one form into another, which the artist began to exploit for the sake of creating an interesting pattern of marks that keep the eye of the viewer moving in an interesting way throughout the drawing.

CONTINUED ON NEXT PAGE

At this stage of the drawing, the artist chose to remove the grid from the table in order to view the still life setup unobstructed and in its entirety. The artist was confident that the proportions of the objects were accurate and placed on the table using correct perspective. You'll notice that most of the corresponding grid lines on the paper have been erased; this is because the artist felt that they were no longer necessary.

The overall design of the drawing was defined by the lightening or de-emphasizing of lines. The artist wanted some of the lines to remain in the background and strengthened those lines that gave a sense of form to the objects and the drawing's composition. The shapes of the objects have also been refined, including more of the details in the palm fronds and specific characteristics pertaining to each object.

At this point, it's important to be very selective about what you add to and eliminate from the drawing. Here, the artist almost completely focused on the rhythm of shapes throughout the picture. With a little shading in the shell, the plant, the interior of the pot, as well as the central vertical frond of the palm plant, more strength was added to the design, which also enhanced the drawing spatially. There are many ways of shading a line drawing, some of which you have seen in the various examples shown earlier in this chapter.

In order to retain a consistency of technique, the artist chose to use thin, parallel lines placed closely together which follow the form.

TIP

Lighten an Area
Inevitably, there will be areas of your line drawing that you'll want to lighten, without completely erasing what you have drawn. To do this, you can take your clean, kneaded eraser and blot the areas that you feel are too dark. You can also lightly rub the eraser over the lines to take away some graphite.

CONTINUED ON NEXT PAGE

Near the final stages of the line drawing, the artist continued the same process from the previous step—lightening some areas considerably to allow them to recede and form a less important role in the drawing. The eye of the viewer is naturally attracted to the contrast that was created between the darker lines and marks in the drawing and the white paper. Because of this, the dark accents and heavier lines play a key role in directing the path the viewer takes in the work.

Still Life in Line, *by Dean Fisher*

Of course, it is always difficult to decide when a work is finished; this is undoubtedly one of the most difficult aspects of being an artist. You may feel the work is finished one day, and then a week later, you may see several things that you'd like to change.

Time is always the best test to determine whether a work is finished or not. (Perhaps if you're working with a model, they may cooperate with your need for additional time!) When you return to the work a number of times and you are at a loss as to what you can do to make any improvements, then that is when it's complete.

In this section, you can see four different approaches to drawing a portion of the palm frond. These are only a few of the many ways that you can approach this subject using line drawing. Notice how each of the examples creates an entirely different effect from the others.

This drawing was made with a thin, black ball-point pen. There was a conscious effort to keep the pen on the paper, with one unbroken uniform line, while drawing each individual palm frond. The pattern of positive and negative shapes shown here was created by the overall forms of the leaves, rather than by attempting to precisely describe each form. When attempting a drawing such this, you can very lightly draw the object with an H or 2H pencil to give yourself a guide to use.

This example was drawn on a lightly textured paper with medium-hard charcoal. The artist wanted to draw the shapes of the palm frond quickly and energetically, with a fair amount of variation, from very dark and heavy to lighter and thinner. The shapes of the palm frond lent themselves to energetic, sweeping lines in this drawing. It is often the subject that sparks the idea to experiment with a new technique.

This drawing was intended to make a bold statement in almost a graphic way with its continuous heavy, black charcoal line. Because of its uniform line, it is perceived in a flatter, more two-dimensional way than the drawings that have a more varied line. The strength of the line and the emphasis on the spiky shapes of the palm fronds give the drawing an aggressive appearance.

This line drawing was executed with a 2H pencil on lightly textured drawing paper. It was drawn with repetitive light, sweeping, gestural lines. The artist consciously tried not to find the correct line the first time, but rather to approach the correct form through a succession of lines. Notice how the numerous gentle lines impart a feeling of movement. The initial lines that were drawn to capture the overall shape of the fronds were left, as they enhanced this feeling of movement.

Palm Frond Studies, *by Dean Fisher*

In this still-life line drawing, the artist used a fairly consistent, heavy line throughout. However, on careful observation, you can see subtle breaks in the lines, as well as a number of darker, accentuated lines. On many of the openings of the objects, the far side of the ellipse was drawn more lightly, along with a few carefully placed interruptions in the lines. This gives the effect of the shape receding in space. Notice that the reflections were also drawn more lightly; this is an effective device that separates the solid objects from their mirror images.

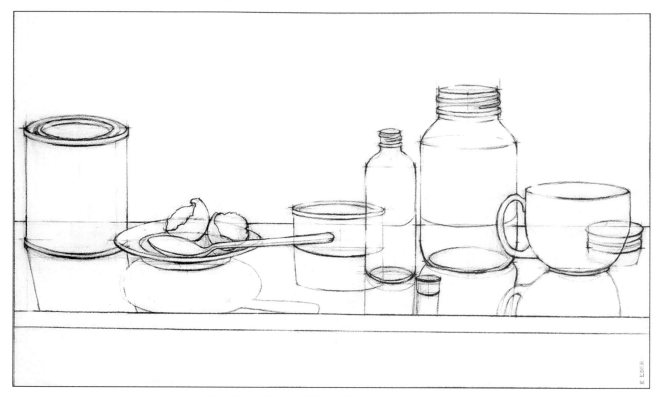

Containers #2, by Eileen Eder, courtesy of artist

In this drawing of an elderly woman, there is a unity created, with the darker, rhythmic lines representing the outline of the face and features. The lighter, fluid lines represent the recesses and lines of the woman's face. The quality of the line is skillfully varied for visual interest, as well as describing the structure of a human head. The top portion of the head diminishes into the whiteness of the paper, which gives the effect of light falling over the form. You can almost imagine the parts of the head that weren't drawn due to the accuracy and sensitive observation of the portions that were rendered.

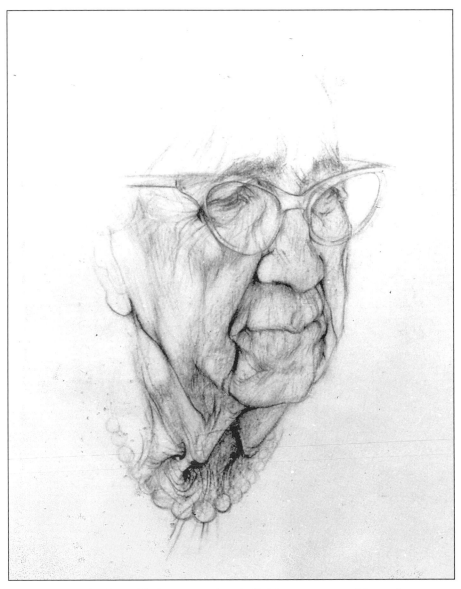

Portrait of an Elderly Woman, *by Shell Fisher, courtesy of the artist*

CONTINUED ON NEXT PAGE

In this deftly executed figure composition, Rubens has masterfully rendered a scene of a group of figures in motion by using a flurry of lines of varying thicknesses. This was most likely a preparatory sketch for a painting, with the artist working from memory. Notice the complete unity between the quality and direction of lines, the gestures of the figures, and the composition. Because of the swiftness of the line, it is as if the drawing was blown across the page in a moment. Notice the faintly drawn figures in the distance, and the great effect of atmosphere and space that is created.

The Feast of Herod, *by Peter Paul Rubens, © Cleveland Museum of Art*

In this economically drawn rendering of a reclining figure, the artist has used so few lines that you can almost count them. However, because of their proper placement and linear accuracy, the illusion is successful. In most cases, the darker lines are placed in areas where the artist wanted the form to emerge, but a dark accent can also be used in an area that recedes, such as the recess of the right armpit. Contrasted with the light falling on the top of the torso, this dark accent, skillfully placed, gives a great three-dimensionality to the form.

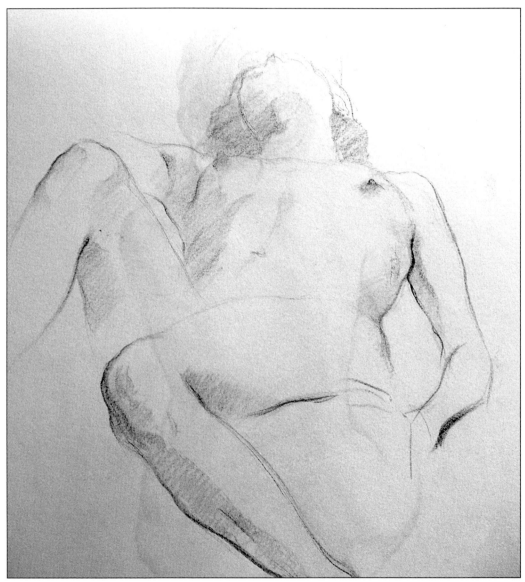

Reclining Nude, *by Silvius Krecu, courtesy of the artist*

CONTINUED ON NEXT PAGE

A wiggly, almost trembling line was used throughout this still life drawing, which animates the objects drawn and gives them great character. There is a clear feeling for the speed with which the drawing was executed. The similar line, which changes from light to quite dark and heavy, is used to create a different local color or tone in each object, and at the same time, it literally ties all of the objects together.

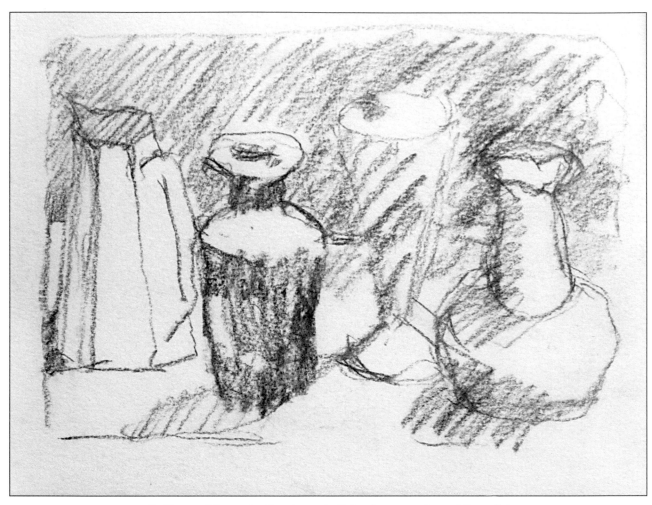

Bottles and Vases, *by Constance LaPalombara, courtesy of the artist*